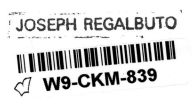
The Flame of Recognition

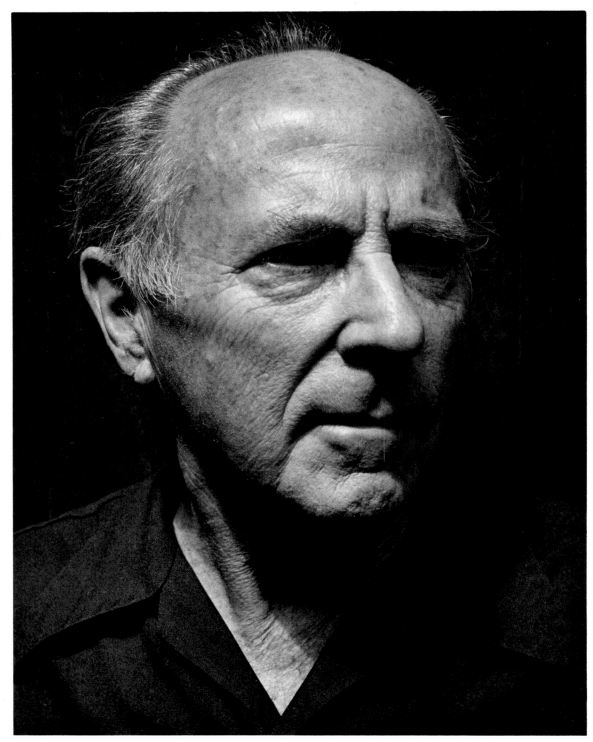

Photograph by Ansel Adams

EDWARD WESTON

The Flame of Recognition

His photographs
accompanied by excerpts from the Daybooks & Letters

Edited by NANCY NEWHALL

AN APERTURE MONOGRAPH

CONTRIBUTORS

BRETT WESTON, photographer, second son of Edward and taught by him to photograph; exhibited with him from age of 14 onward; frequently shared studio together. Guggenheim Fellow 1947; traveled across United States. Lives in Carmel.

DODY, photographer and writer, apprentice to Edward, third wife of Brett. Assisted Clyde Lou Stoumen in making movie *The Naked Eye.*

ANSEL ADAMS, photographer, writer, teacher, musician, conservationist. Member with Edward of Group *f*64. Published Weston's MY CAMERA ON POINT LOBOS, 1950.

BEAUMONT NEWHALL, writer, art historian, teacher, Curator of Photography, Museum of Modern Art, 1940-1946. Curator and then Director of the George Eastman House, Rochester, N.Y., 1948-1971. Now Visiting Professor, University of New Mexico.

NANCY NEWHALL, writer, exhibit maker, wife of historian Beaumont Newhall. Acting Curator of Photography, Museum of Modern Art, 1942-1946. Directed Weston's retrospective and wrote accompanying monograph. Author of several books with and about photographers; working on biography of Weston. As guest editor of this issue selected texts and pictures.

COLE WESTON, photographer, actor; 4th son of Edward Weston and the executor of his estate. All extant negatives and many original prints still in his care. *Inquiries about purchase, exhibitions, permission to reproduce, etc. should be addressed to:* COLE WESTON, Box 4886, Carmel, California.

Copyright © 1965, 1971 by Aperture, Inc. All rights reserved under International and Pan-American Copyright Conventions. Published in the United States by Aperture, Inc., Elm Street, Millerton, New York 12546. Distributed in the United States by Harper & Row, Publishers, Inc.; in the United Kingdom, Commonwealth, and other world markets by Phaidon Press Limited, Oxford; in Canada by Van Nostrand Reinhold, Ltd.; and in Italy by Idea Books, Milan.

Library of Congress Catalog Card Number 652407
ISBN 0-912334-02-9 Clothbound
ISBN 0-912334-03-7 Paperbound
ISBN 0-912334-71-1 Museum of Modern Art Paperbound

Manufactured in the United States of America. Printed by Rapoport Printing Corp. and bound by Sendor Bindery.

Aperture, a nonprofit, educational organization, publishes a quarterly of photography, books, and portfolios to communicate with serious photographers and creative people everywhere.

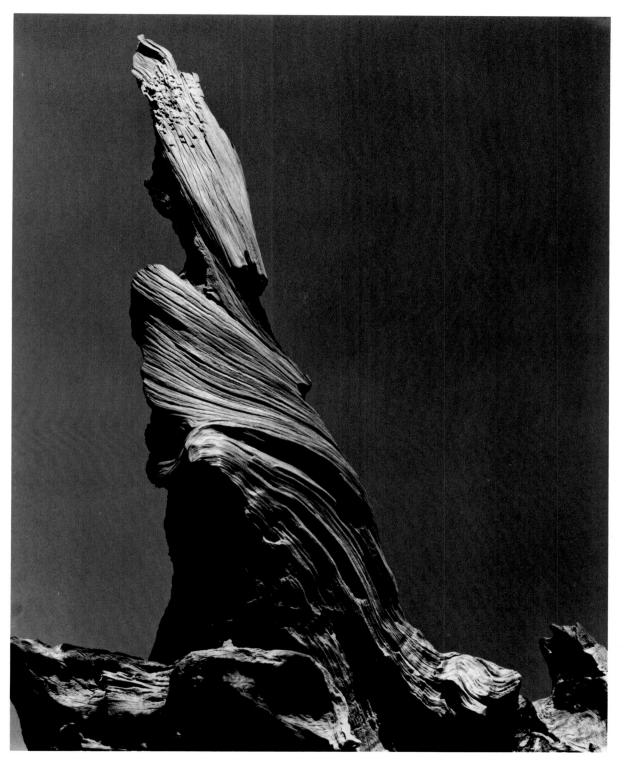

SNAG Point Lobos 1930

Foreword

In his daybooks, Edward Weston was trying to focus himself as man and photographer. To be alone and to think, free for an hour of family, friends, loves, he rose in the dark before dawn and poured down on the page in his massive scrawl whatever was seething in him. The "headaches, heartaches, bellyaches" he later found so revolting that in 1923 he burned all except six or seven pages, and in the 1940s when publication of the daybooks just as they stood was proposed, he went through them with a razor cutting out names and comments until the pages were full of holes and sometimes sliced to ribbons. What endured for him, as for us, are his attempts to analyze his change and growth and—"my work is always a few jumps ahead of what I write about it"—to understand the strange flashes of vision that came through his camera.

In photography he had had to find his way alone, first because as a boy he was too shy to ask and later because, when the fashionable attitudes and easy successes were behind him, the only photographers who would have understood him were, so far as he knew, three thousand miles away on the East Coast. He did see them once, briefly on a journey to New York City in 1922. The rest of the years he wrestled alone with his medium and himself. Painters, poets, dancers, musicians among his friends helped by their affirmations and insights into his work; great art, especially music, helped him form his goals. But how in a medium so young, so little understood, did one define art? And how could a creator live?

Films were slow in those days and exposures long; his old 8 x 10 was rickety and his bellows often leaked. And to the last, he trusted his own feeling for light more than any photoelectric meter. Deliberately he stripped his technique, his living, and seeing of unessentials and tried to concentrate on the objective and eternal—only to find that he could not and would not be bound even by his own dogma. How could he tell what he would see on his ground glass tomorrow?

In the early 1930s he ceased to be alone; his own sons were growing up, other young photographers were coming to share the search, he had love and companionship in his work. And he had solved his basic problems; he had world-wide recognition. The daybooks ceased in 1934, partly because the need for them had ceased, partly because he had always doubted his ability to write. From then on we glimpse the movements of his thought through his letters.

*In this special issue of **aperture**, Edward Weston speaks for himself, in his own words and photographs, of his long search **"to present clearly my feeling for life with photographic beauty . . . without subterfuge or evasion in spirit or technique."***

Nancy Newhall

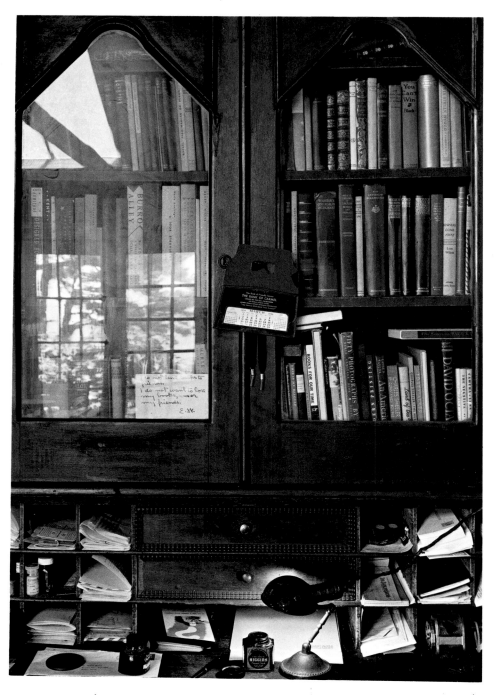

Dody

2-21-'31

Peace again! — The exquisite hour
before dawn, here at my old desk ———
seldom have I realized so keenly,
appreciated so fully, these still,
dark hours.

The Flame of Recognition

The flame started first by amazement over subject matter, that flame which only a great artist can have—not the emotional pleasure of the layman—but the intuitive understanding and recognition relating obvious reality to the esoteric, must then be confined to a form within which it can burn with a focused intensity: otherwise it flares, smokes and is lost like in an open bonfire.

So writing I do not place the artist on a pedestal, as a little god. He is only the interpreter of the inexpressible, for the layman, the link between the known and the unknown, the beyond. This is mysticism,—of course! How else can one explain why a combination of lines by Kandinsky, or a form by Brancusi, not obviously related to the cognized world, does bring such intense response. . . . Granted the eye becomes excited, Why?

July 26, 1929 Carmel

I recall my dissatisfaction before going to New York, 1922. I was changing, and going in the right direction too: Stieglitz—my two hours with him focused me. Yet "Steel" and several other things made in Ohio, before seeing Stieglitz, were a forecast of my present work. In fact, I still show them as part of my present.

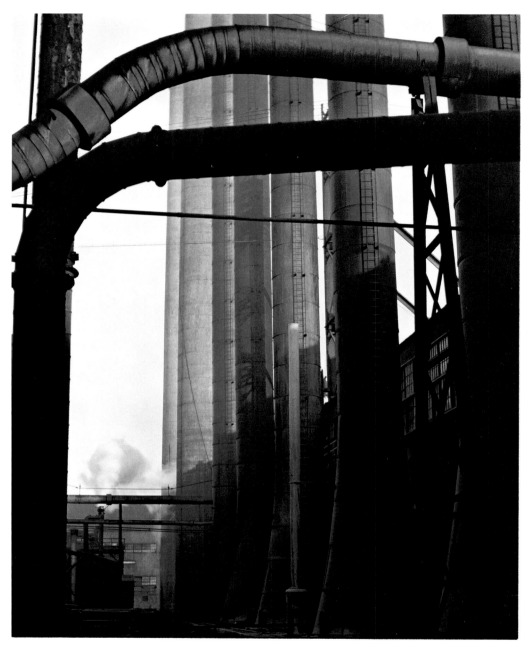

ARMCO STEEL Ohio 1922

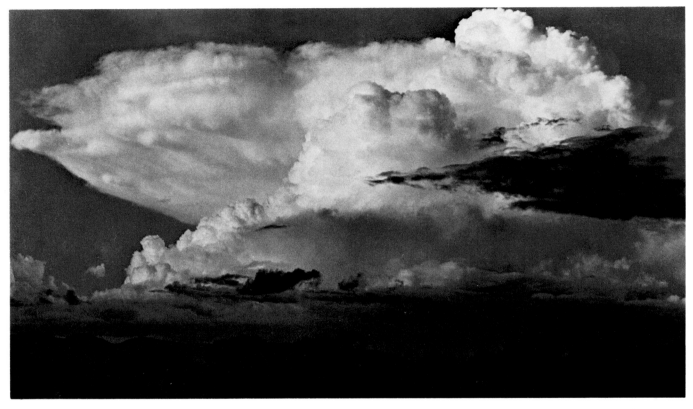

CREPUSCULO 1924

September 13, 1923 Mexico City
I should be photographing more steel mills or paper factories, but here I am in romantic Mexico, and, willy-nilly, one is influenced by surroundings. I can, at least, be genuine. Life here is intense and dramatic, I do not need to photograph premeditated postures, and there are sunlit walls of fascinating surface textures, and there are clouds! They alone are sufficient to work with for many months and never tire.

January 7th, 1924 Mexico City

I am finishing the portrait of Lupe. It is a heroic head, the best I have done in Mexico. With the Graflex, in direct sunlight I caught her, mouth open, talking and what could be more characteristic of Lupe. Singing or talking I must always remember her.

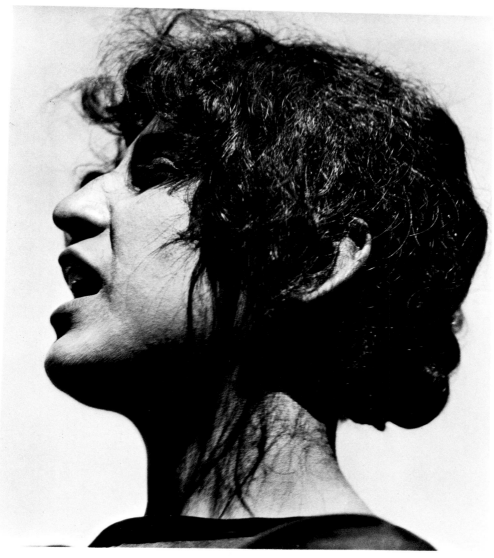

GUADALUPE MARIN de RIVERA

February 3rd, 1924 Mexico City

I wanted to catch Galván's expression while shooting. We stopped by an old wall, the trigger of his Colt fell, and I released my shutter. Thirty paces away a peso dropped to the ground.

March 10th, 1924 Mexico City

For what end is the camera best used? . . . The answer comes always more clearly after seeing a great work of the sculptor or painter . . . that the camera should be used for a recording of *life,* for rendering the very substance and quintessence of the *thing itself,* whether polished steel or palpitating flesh.

I see in my recent negatives . . . pleasant and beautiful abstractions, intellectual juggleries which presented no profound problem. But in the several new heads of Lupe, Galván, and Tina I have caught fractions of seconds of emotional intensity which a worker in no other medium could have done as well . . . I shall let no chance pass to record interesting abstractions but I feel definite in my belief that the approach to photography—and its most difficult approach—is through realism.

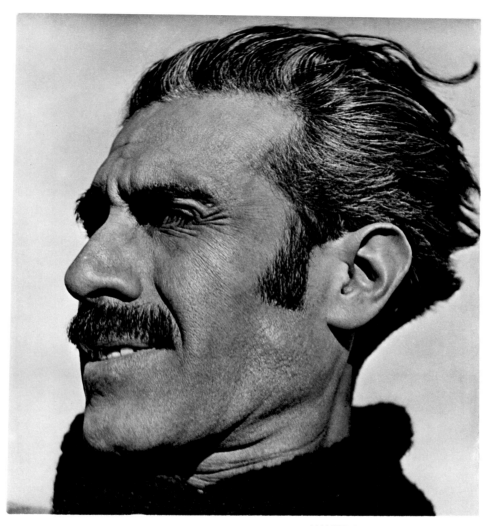

MANUEL HERNANDEZ GALVAN 1924

October 4, 1924 Mexico City

Tina sat to me yesterday morning. We had long planned that I should do her as I have often seen her, quoting poetry—to attempt the registration of her remarkably mobile face in action. There was nothing forced in this attempt, she was soon in a mood which discounted me and my camera—or did she subconsciously feel my presence and respond to it? Within twenty minutes I had made three dozen Graflex negatives and caught her sensitive face with its every subtle change.

October 6

We have been like a couple of happy excited children, Tina and I, over the results of our recent sitting—but also sad with disappointment, for though the series of heads are the most significant I have ever made, though my vision on the ground glass and my recognition of the critical moment for release were in absolute accord with her emotional crises, I failed technically through underexposure, just the slight undertiming which destroys chemical continuity in a set of negatives made under a strong over-head light.

But why should I of all persons fail on exposure? I had figured to a nicety, 1/10 sec., $f/11$, Panchro film, Graflex, knowing though that I was on the borderland of underexposure. I had placed Tina in a light calculated not to destroy expression in her eyes, and then to augment it cast reflected light down from above with an aluminum screen—an unusual procedure for me—to be using light accessories. But the sun moves in its orbit, and I, working in a state of oblivion, did not note that my reflector no longer reflected! I feel the weakness of my excuse, my intellect should not have been overwhelmed by my emotions, at least not in my work!

With a stand camera, my hand on the bulb, watching my subject, there is a coordination between my hand and brain: I *feel* my exposure and almost unconsciously compensate for any change of light. But looking into a Graflex hood with the shutter set at an automatic exposure, a fixed speed, is for me quite different. I dislike to figure out time, and find my exposures more accurate when only *felt.*

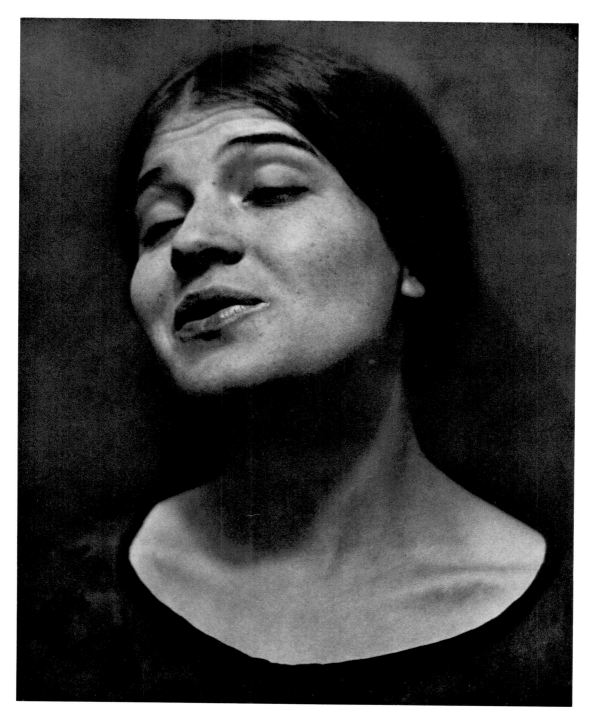

TINA

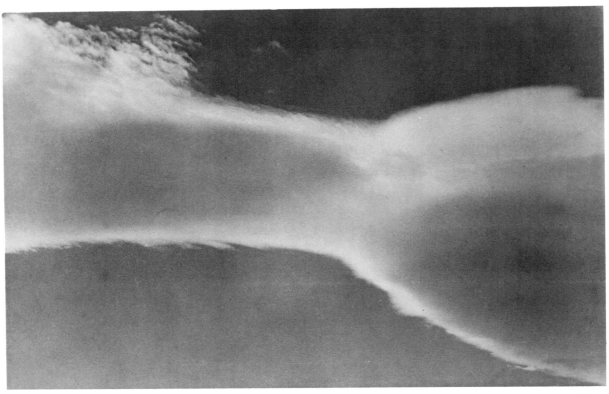

CLOUD

July 9, 1924 Mexico City

Clouds have been tempting me again. Next to the recording of a fugitive expression, or revealing the pathology of some human being, is there anything more elusive to capture than cloud forms! And the Mexican clouds are so swift and ephemeral, one can hardly allow the thought, "Is this worth doing?" or "Is this placed well?" —for an instant of delay and what was, is not! The Graflex seems the only possible way of working. Yesterday's results gave me one negative worth considering: to be sure I made but three, but time and patience were spent in waiting and studying.

My eyes and thoughts were heavenward indeed—until, glancing down, I saw Tina lying naked on the azotea taking a sun-bath. My cloud "sitting" was ended, my camera turned down toward a more earthly theme, and a series of interesting negatives was obtained. Having just examined them again I am enthusiastic and feel that this is the best series of nudes I have done of Tina.

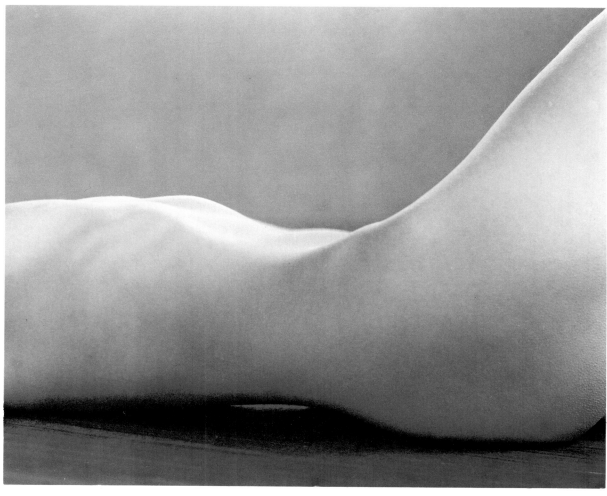

NUDE

November 12, 1925 Mexico City

Peace and an hour's time—given these, one creates. Emotional heights are easily attained; peace and time are not.

Yesterday I "created" the finest series of nudes I have ever done, and in no exalted state of mind. I was shaving when A. came, hardly expecting her on such a gloomy, drizzling day. I made excuses, having no desire—no "inspiration"—to work. I dragged out my shaving, hinting that the light was poor, that she would shiver in the unheated room. But she took no hints, undressing while I reluctantly prepared my camera.

And then appeared to me the most exquisite lines, forms, volumes. And I accepted, working easily, rapidly, surely.

April 14th, 1926 Mexico City

In trying to analyze my present work as compared to that of several years ago, I can best summarize that once my aim was interpretation; now it is presentation. Also, I could now, with opportunity produce one or more significant photographs a day 365 days a year. Any creative work should function as easily and naturally as breathing.

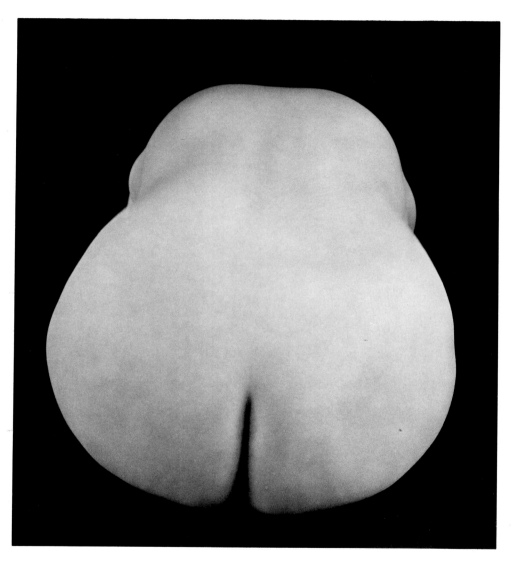

NUDE 1925

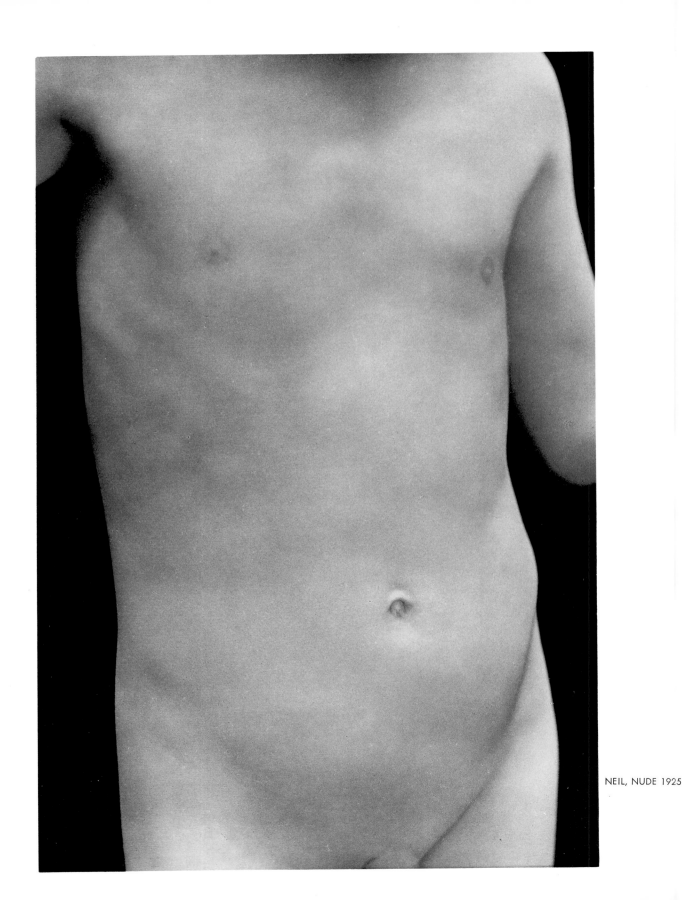

NEIL, NUDE 1925

December 19, 1925 Mexico City

Besides Neil's companionship . . . he afforded me a visual beauty which I recorded in a series of Graflex negatives of considerable value. He was anxious to pose for me, but it was never a "pose," he was absolutely natural and unconscious in front of the camera. When I return he may be spoiled, if not bodily changed, in mental attitude. Last spring in San Francisco at eight years, he was in the flower of unawakened years before adolescence: tall for his years, delicately moulded, with reedlike flow of unbroken line; rare grey eyes, ingenuous, dreaming, and a crown of silken blond hair. He is a lovely child!

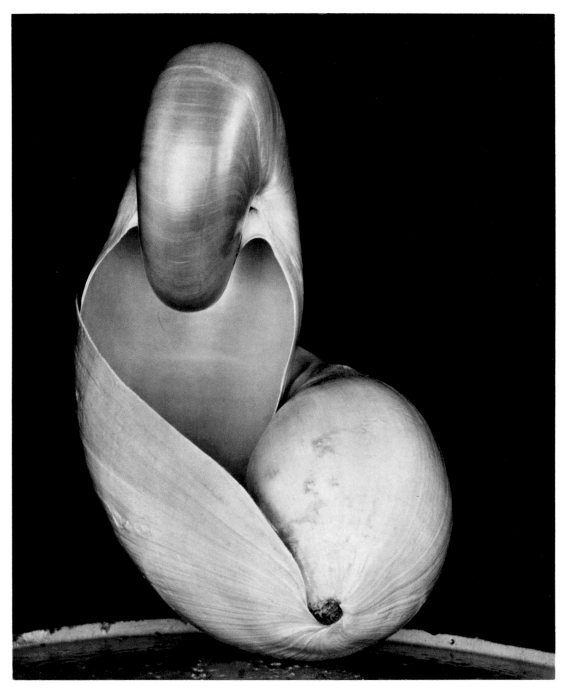

TWO SHELLS 1927

March 30, 1927 Los Angeles
The shells I photographed were so marvelous one could not do other than something of interest. What I did may be only a beginning.

April 28, 1927 Los Angeles
Every day finds me working, or at least thinking of work for myself,—and with more enthusiasm, surety and success than ever before. Another shell negative,—another beginning of something, from yesterday.

One of these two new shells when stood on end, is like a magnolia blossom unfolding. The difficulty has been to make it balance on end and not cut off that important end, nor show an irrelevant base. I may have solved the problem by using another shell for the chalice, but I had the Devil's own time trying to balance those two shells together. In the first negative they slipped just a hair breadth,—and after a three hour exposure! The second attempt is technically good.

I feel that I have a number of exceedingly well seen negatives,—several which I am sure will live among my best.

Monday Morning Los Angeles
I worked all Sunday with shells,—literally all day. Only three negatives made and two of them were done as records of movements, to repeat again when I can find suitable backgrounds. I wore myself out trying every conceivable texture and tone for grounds: glass, tin, cardboard,—wool, velvet, even my rubber rain coat! I did not need to make these records for memory's sake,—no, they are safely recorded there. I did wish to study the tin which was perfect with the lens open: but stopped down I could not see sufficiently to tell, but was positive the surface would come into focus and show a network of scratches: it did. My first photograph of the Chambered Nautilus done at Henry's [Henrietta Shore, painter] was perfect all but the too black ground: yesterday the only available texture was white. Again I recorded to study at leisure the contrast. The feeling of course has been quite changed,—the luminosity of the shell seen against the black, gone: but the new negative has a delicate beauty of its own. I had heart failure several times yesterday when the shells, balanced together, slipped. I must buy a Nautilus for to break Henry's would be tragic.

July 25, 1927 Glendale, California
I must take time to write about the reactions to my shell prints, as written by Tina from Mexico after showing them to several old acquaintances. First, to quote briefly the most salient remarks.

"My God Edward, your last photographs surely took my breath away. I feel speechless in front of them. What purity of vision. When I opened the package I couldn't look at them very long, they stirred up all my innermost feelings so that I felt a physical pain."

 Later—same morning—
"Edward—nothing before in art has affected me like these photographs. I cannot look at them long without feeling exceedingly perturbed, they disturb me not only mentally but physically. There is something so pure and at the same time so perverse about them. They contain both the innocence of natural things and the morbidity of a sophisticated, distorted mind. They make me think of lilies and embryos. They are mystical and erotic—"

Same day—evening—
—after showing them to Felipe and Pepe—

"On the whole their reactions were very similar to mine—Felipe was so carried away, he made an impulsive promise to write you.

"We spent about two hours discussing the photographs and all kinds of problems stimulated by them. Since the creation of an artist is the result of his state of mind and soul at the time of creation these last photographs of yours clearly show that you are at the present leaning toward mysticism.

"At the same time they are very sensuous."

Next morning—

"Last eve, Réné called. Without my saying a word he used 'erotic' also. Like me he expressed the disturbance these prints caused him. He felt 'weak at the knees'."

July 4

"At last Diego saw your photographs! After the first breath-taking impression was over, and after a long silent scrutiny of each, he abruptly asked: 'Is Weston sick at present?' Then he went on: 'These photographs are biological, beside the aesthetic emotion they disturb me physically—see, my forehead is sweating.' Then—'Is Weston very sensual?' Then—'Why doesn't Weston go to Paris? Elie Faure would go wild over these things!' "

July 7th

"Last evening Orozco was here—I got out the shell prints. Well, in a few words, he liked them better than all your collection put together. Of one he said, 'This suggests much more the "Hand of God", than the hand Rodin made.' It is the one that has made everybody, including myself think of the sexual act."

From the above quotations, it will be seen that I have created a definite impression, but from an angle which surprised me!

Why were all these persons so profoundly affected on the physical side?

For I can say with absolute honesty that not once while working with the shells did I have any physical reaction to them; nor did I try to record erotic symbolism. I am not sick and I was never so free from sexual suppression —which if I had, might easily enter into my work.

I am not blind to the sensuous quality in shells, with which they combine the deepest spiritual significance: indeed it is this very combination of the physical and the spiritual in a shell like the Chambered Nautilus, which makes it such an important abstract of life.

No! I had no physical thoughts,—never have. I worked with clearer vision of sheer aesthetic form. I know what I was recording from within, my feeling for life as I never had before. Or better, when the negatives were actually developed, I realized what I had felt,—for when I worked, I was never more unconscious of what I was doing.

No! The Shells are too much a sublimation of all my work and life to be pigeon-holed. Others must get from them what they bring to them: evidently they do!

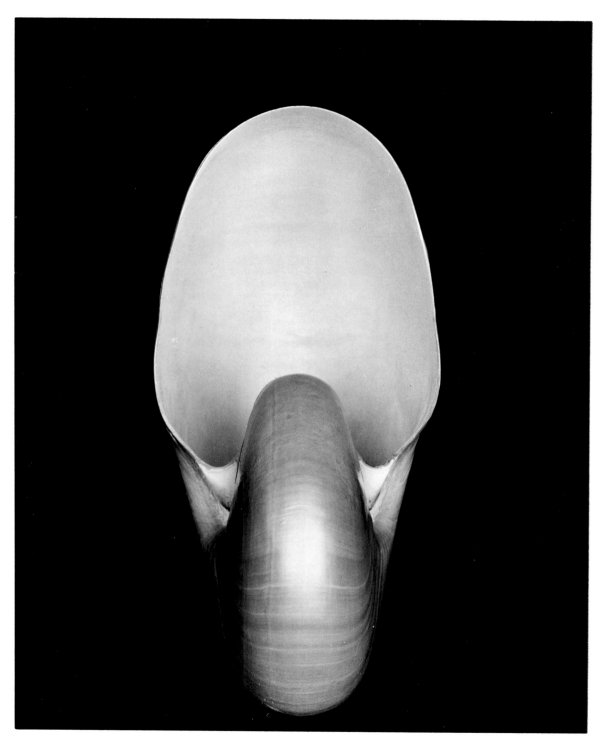

SHELL 1927

March 2nd, 1929 Carmel

The 1st of March I should write in Color and Capitals—I started my work again!—and in the most exciting environs,—the Big Sur. We left Carmel at dawn, and returned at dusk. The excursion was exciting, over a steep tortuous road high upon the cliffs overlooking the Pacific, then down into valleys, hardly more than cañons, where great Redwoods, majestically silent, towered toward the light. The coast was on a grand scale: mountainous cliffs thrust buttresses far out into the ocean, anchored safely for an eternity: against the rising sun, their black solidity accentuated by rising mists, and sunlit water. But I lack words, I am inarticulate, anything I might write would sound as trivial as "ain't nature grand." I hope the one negative made from this point will in a small way record my feeling. My desert rocks were much easier to work with, and quite as amazing, or more so. They were physically approachable, I could walk to their very base, touch them. At Big Sur, one dealt with matter from hundreds of feet to many miles distant. The way will come in time to see this marriage of ocean and rock. Yet I did respond—it is rather that I must find the right spot to see clearly with my camera.

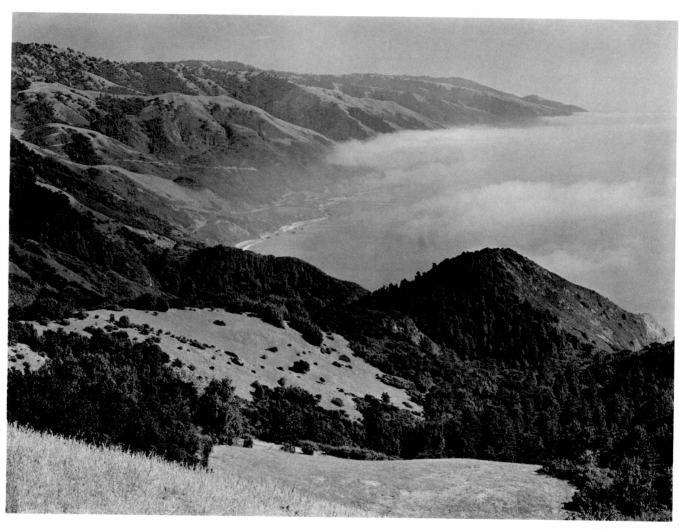

THE BIG SUR 1945

April 21st, 1929 Carmel

Point Lobos! I saw it with different eyes yesterday than those of nearly fifteen years ago. And I worked, how I worked! And I have results! And I shall go again, and again! I did not attempt the rock, nor any general vista; I did do the cypress! . . . Details, fragments of the trunk, the roots—dazzling records . . . Brett and Merle Armitage exclaimed over the negatives; one "like a flame," Merle said . . . Amazing trees! those stark, bone-white, aged ones, storm swept and twisted into the most amazing forms.

Sunday . . . I have never made a negative that pleased me more.

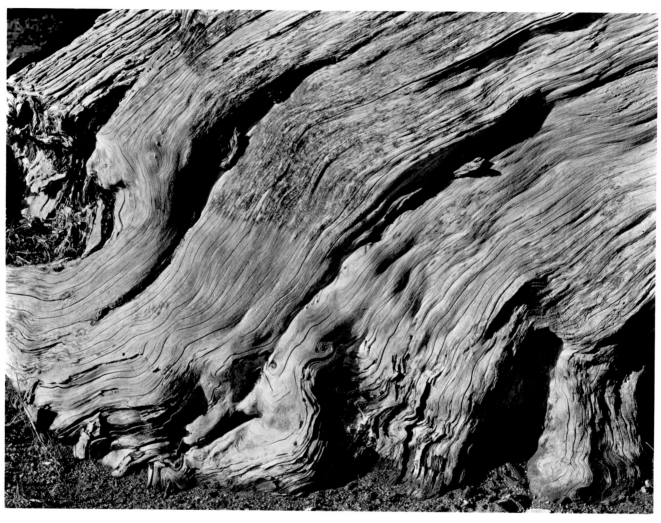

CYPRESS Point Lobos 1929

Wednesday 15th (May?) 1929 Carmel

Fog drifted in, dulling the sky, obliterating the horizon, before I had even started for Jeffers' home. I planned to do him out of doors, in the surroundings that belong to him,—the rocks and ocean. The heavy sky was suitable in mood but sunlight would have carved his rugged face into more revealing planes. I made but twelve negatives, mostly profiles against the sky, and then quit until the next time.

I couldn't get into the sitting: the light so flat—and then finding him unexpectedly conscious, not nervous as some are in front of a camera—that tendency can usually be overcome, but Jeffers really posed, tried to appear as he thought he should be seen. I caught him looking out of the corner of his eye at me, and then would come a definite attempt to assume a pose—throwing back the head, feeling the part he was to play. This was disconcerting.

I am inclined to think there is much "bunk" talk about Jeffers,—about his way of working, unconscious of what he is doing. Any great man, artist, is quite aware—conscious of his unconscious, if that means anything, if my words make clear my thought. And so Jeffers.

May 18th, 1929

I wrote of Jeffers, "he tried to appear as he thought he should be seen." Maybe I should have written "as he *knew* he should be seen." For a man to know himself is legitimate, indeed quite right.

May 29th, 1929

I made three dozen negatives of Jeffers—used all my negatives; and developed the moment I got home. It was another grey day, but now I realize, knowing him better, that Jeffers is more himself on grey days. He belongs to stormy skies and heavy seas. Without knowing his work one would feel in his presence greatness.

I did not find him silent—rather a man of few words. Jeffers' eyes are notable: blue, shifting—but in no sense furtive—as though they would keep their secrets,—penetrating all-seeing eyes. Despite his writing I cannot call him misanthropic; his is the bitterness of despair over humanity he really loves.

June 6th, 1929

And today the Jeffers leave for Ireland. Sonya and I walked out to say goodby and take them several of his portraits. They were so pleased with them. Una Jeffers said: "Robin will never again have such fine portraits, unless you make them."

ROBINSON JEFFERS Tor House 1929

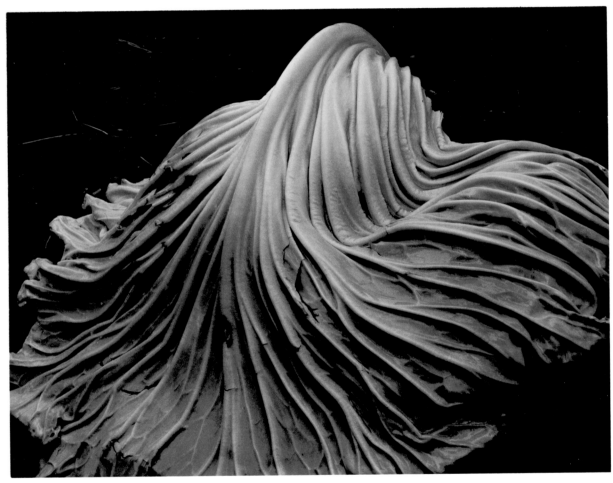

CABBAGE LEAF 1931

July 9th, 1930  Carmel

I have worked with summer squash—one afternoon making some very beautiful and strong negatives: the squash nearly white in the sun, a grey ground and intense black shadow—the simple massing of the values most satisfying. And I have worked with peppers again, surprising myself! Sonya brought several home, and I could not resist, though I thought to have finished with peppers. But peppers never repeat themselves: shells, bananas, melons, so many forms are not inclined to experiment—not so the pepper, always excitingly individual. So I have three new negatives, and two more under way.

August 1st, 1930

The glorious new pepper Sonya brought has kept me keyed up all week and caused me to expose eight negatives— I'm not satisfied yet! These eight were all from the same viewpoint; rare for me to go through this. I started out with an under exposure—by the time I had developed the light had failed, and though I tripled my time again I undertimed! Again I tried, desperately determined to get it because I could ill afford the time. Giving an exposure of 50 minutes at 5:00 o'clock I timed correctly but during exposure the fire siren shrieked and promptly the fire truck roared by followed by every car in town: the old porch wobbled, my wobbly old camera wobbled, the pepper shimmied, and I developed a moved negative.

Next morning I went at it again: interruptions came, afternoon came, light weak, prolonged exposures necessary, —result, one negative possible, but possible also to improve upon it.

I tried the light from the opposite side in the next morning light,—brilliant sun through muslin. Better! And more failures, this time sheer thoughtlessness: a background of picture backing was placed too close and came into focus when stopped down which I could not see but should have realized, the corrugations plainly show and spoil the feeling. So I have made eight negatives from the same angle and still must go on.

Today is foggy and I am faced with an entirely new approach.

All this work has been done between moments of greeting tourists, printing, mounting, etc. Small wonder I've failed!

But the pepper is well worth all the time, money, effort. If peppers would not wither, I certainly would not have attempted this one when so preoccupied. I must get this one today; it is beginning to show signs of strain and tonight should grace a salad. It has been suggested that I am a cannibal to eat my models after a master-piece. But I rather like the idea that they become a part of me, enrich my blood as well as my vision. Last night we finished my now famous squash, and had several of my bananas in a salad.

33

August 3rd

Sonya keeps tempting me with new peppers! Two more have been added to my collection. While experimenting with one of these, which was so small I used my 21 cm Zeiss to fill the 8 x 10 size, I tried putting it in a tin funnel for background. It was a bright idea, a perfect relief for the pepper and adding reflected light to important contours. I still had the pepper which caused me a week's work. I had decided I could go no further with it, yet something kept me from taking it to the kitchen, the end of all good peppers. I placed it in the funnel, focused with the Zeiss, and, knowing just the viewpoint, recognized a perfect light, made an exposure of six minutes, with but a few moments preliminary work—the real preliminary was done in hours passed. I have a great negative—by far the best.

August 8, 1930

I could wait no longer to print them—my new peppers, so I put aside several orders, and yesterday afternoon had an exciting time with seven new negatives.

First I printed my favorite, the one made last Saturday, August 2, just as the light was failing—quickly made, but with a week's previous effort back of my immediate, unhesitating decision. A week?—yes, on this certain pepper—but twenty years of effort, starting with a youth on a farm in Michigan, armed with a No. 2 Bull's Eye Kodak, 3½ x 3½, have gone into the making of this pepper, which I consider a peak of achievement.

It is classic, completely satisfying,—a pepper—but more than a pepper: abstract, in that it is completely outside subject matter. It has no psychological attributes, no human emotions are aroused: this new pepper takes one beyond the world we know in the conscious mind. To be sure much of my work has this quality,—many of my last year's peppers, but this one, and in fact all the new ones, take one into an inner reality—the absolute— with a clear understanding, a mystic revealment. This is the "significant presentation" that I mean, the presentation through one's intuitive self, seeing "through one's eyes, not with them"; the visionary.

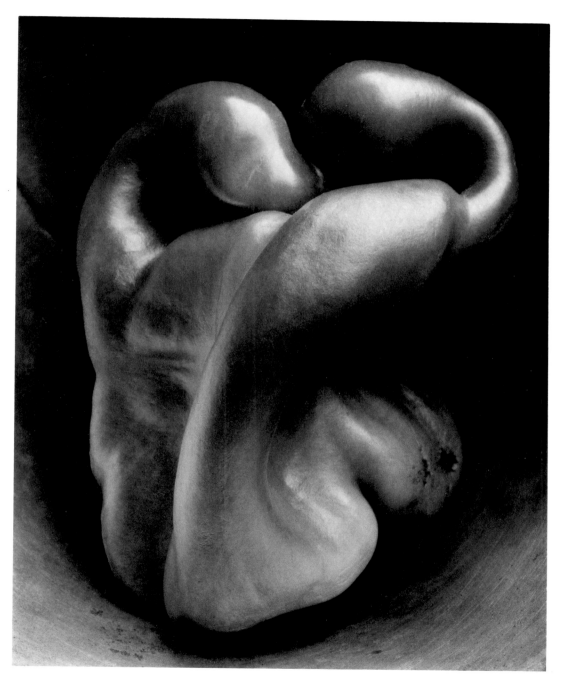

PEPPER No. 30, 1930

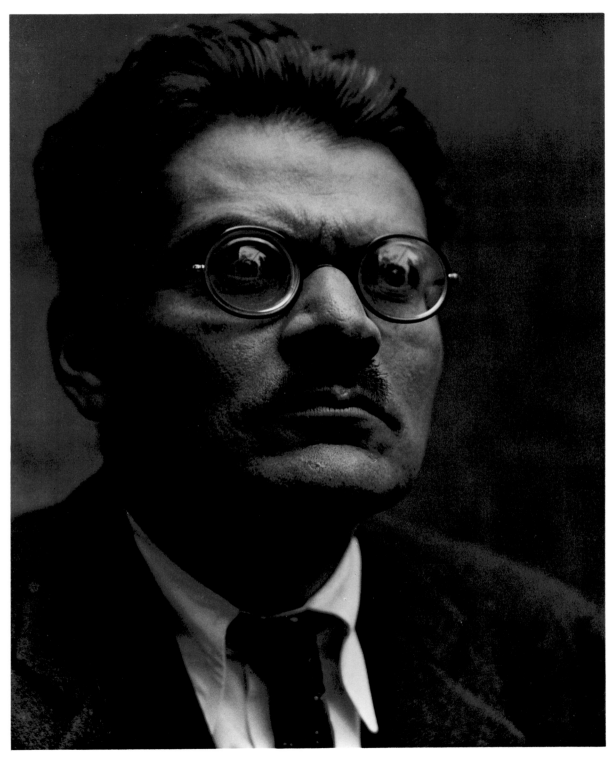

JOSE CLEMENTE OROZCO

August 27, 1930 Carmel

Orozco—one of my finest portraits, his piercing eyes I accentuated by using to great advantage the reflections from unscreened light upon the thick lenses he wears. Orozco sent word that "it is the first time he has known himself in photographs, in spite of all he has had made." The sitting was made in the failing light of evening after a day crowded with events. Holding the Graflex—there was no time for working with tripod, I could not stop down beyond 6.3, so the definition is not perfect, but practically satisfactory.

May 19, 1930 Carmel

I must dominate in a very subtle way, I must depend upon "chance" if there is such a thing?—to present to me at the moment when my camera is ready, the person revealed, and capture that moment in a fraction of a second or a few seconds, with no opportunity to alter my result . . . Photography's greatest difficulty lies in the necessary coincidence of the sitter's revealment, the photographer's realization, the camera's readiness. But when these elements do coincide, portraits in any other medium, sculpture or painting, are cold dead things in comparison. In the very overcoming of the mechanical difficulties which would seem to restrict the camera (and does if one is not aware and fails to turn these apparent barriers to advantage) lies its tremendous strength. For when the perfect spontaneous union is consummated, a human document, the very bones of life are bared.

May 14, 1929 Carmel

Excitement can come in different ways, mine, through my work. Can I ever forget certain days, periods, places! One of the earliest—the scene in a Chicago apartment, printing from my first negative made with a stand camera purchased with money saved penny by penny, walking ten miles to save ten cents, denying sweets, selling rags and bottles: a second hand camera I had seen in a downtown window, with tripod and a filter it cost $11.00. I can even recall my ecstatic cry as the print developed out—"It's a peach!"—and how I ran, trembling with excitement to my father's library to show this snow scene made in Washington Park—a tree, a winding stream, snow covered banks. I slipped into the stream and rode home on the Cottage Grove cable car with my trouser legs frozen stiff as a board.

My enthusiasm over this print did not last long: I soon realized that the tree was too black, the snow too white, and my struggle began, caused by dissatisfaction, to improve my technique—a long, tough struggle without help for I was a bashful boy, dreading to hear my own voice when making purchases—to ask a question, would have been impossible.

March 15, 1930 Carmel

Long ago I thought of printing my own work—work not done for the public—on high gloss paper. This was some years back in Mexico: but habit is so strong that not until this last month did I actually start mounting glossy prints for my collection . . . hope my next exhibit will be on glossy paper. What a storm it will rouse!—from the "Salon Pictorialists."

It is but a logical step, this printing on glossy paper, in my desire for photographic beauty. Such prints retain most of the original negative quality. Subterfuge becomes impossible; every defect is expressed, all weakness equally with strength. I want the stark beauty that a lens can so exactly render, presented without interference of "artistic effect." Now all reactions on every plane must come directly from the original seeing of the thing, no second hand emotion from exquisite paper surfaces or color: only rhythm, form and perfect detail to consider—first conceptions coming straight through unadulterated—no suggestion, no allegiance to any other medium. . . . Now more than ever, I want to be able—and am most of the time—to make one or two tests, and then the final print, as I would have it. This way is my ideal. It indicates decisive thinking, in making the negative, and carrying that already formed image conception, without wavering, on through into the print. It necessitates fine negatives and printing ability.

April 28, 1930

I have finished, since starting to print on glossy paper, eighty-five prints. All new negatives—that is, those made last year but not printed, and a number of old favorites which have become new favorites, so incomparably finer do they register on glossy paper. It is a joy like unto making a first print, to reprint negatives I was tired of. No other surface is now to be thought of. I can print much deeper than heretofore, with no fear of losing shadows, or muddying half tones by drying down: or I can use a more contrasty grade of paper, resulting in amazingly rich blacks yet retaining brilliant whites.

I actually look forward to the great labor of reprinting all my best work. Then I shall have a bargain sale of the old!

Besides giving me all possible quality from a given negative, glossy paper deprives me of a chance to spot—repair—a print from a damaged or carelessly seen negative. Everything is revealed—retouching on the negative or spotting on the print. One is faced with the real issue, significant presentation of the *Thing Itself* without photographic quality.

June 13, 1930 Carmel

Sometimes being broke, facing an uncertain tomorrow, has a stiffening effect on my spine. It makes me hard, and even reckless in spending, as though I said to myself—I have nothing anyhow—I might as well go to the limit. I bought a new Bach album for $10.00, I decided to put a sign in my showcase, similar to the one on my wall—"no retouching." . . . Now I will change my sign on Ocean Avenue to read "E. W. Photographer—unretouched portraits."

March 21st, 1931 Carmel

My work has vitality because I have helped, done my part in revealing to others the living world about them, showing to them what their own unseeing eyes have missed: I have thus cleared away the haze of a futile romanticism, allowing identification with all things by those who had been drifting apart.

December 3, 1934 Carmel

I am not Metropolitan, left S.F. because I was unhappy, wanted to get my feet on the soil, to get away from canned people. I will return to city life only as a last resort. . . . I will never make money because I don't care enough about it; but I always keep one jump ahead of the wolf, and ask no more! . . . The economic problem is a perennial one which I accept because I made my own choice many years ago. I could have spent time and effort making money; I chose to spend it on my work. . . .

I must do the work that *I* am best suited for. . . .

Thank the Gods we never achieve complete satisfaction. How terrible to contemplate Utopia: Contented Cows.

There is so much talk of the artist getting down to the realities of life. But who is to say which are the realities? Obviously they cannot be the same to everyone. All arguments are futile which do not take into consideration the fact (fact for me at least) that persons differ in *kind,* not just in degree; differ just as horses and elephants do.

But we all have our place, and should function together as a great fugue. And the tension between opposites is necessary.

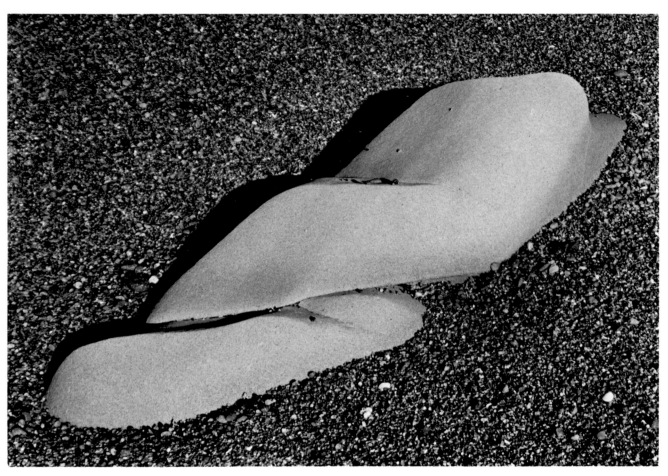

ERODED ROCK No. 51, 1930

April 24, 1930 Carmel

I sent the following statement to Houston, Texas, where I am showing forty prints during May.

Clouds, torsos, shells, peppers, trees, rocks, smokestacks are but interdependent, interrelated parts of a whole, which is life.

Life rhythms felt in no matter what, become symbols of the whole.

The creative force in man recognizes and records these rhythms with the medium most suitable to him, to the object, or the moment, feeling the cause, the life within the outer form. Recording unfelt facts by acquired rule, results in sterile inventory.

To see the *Thing Itself* is essential: the Quintessence revealed direct without the fog of impressionism —the casual noting of a superficial phase, or transitory mood.

This then: to photograph a rock, have it look like a rock, but be *more* than a rock.—Significant presentation—not interpretation.

—and I sent these Technical Notes:

These photographs—excepting portraits—are contact prints from direct 8 x 10 negatives, made with a rectilinear lens costing 500—this mentioned because of previous remarks and questions. The portraits are enlarged from 3¼ x 4¼ Graflex negatives, the camera usually held in hands.

My way of working—

I start with no preconceived idea—discovery excites me to focus—then rediscovery through the lens—final form of presentation seen on ground glass, the finished print pre-visioned complete in every detail of texture, movement, proportion, *before exposure*—the shutter's release automatically and finally fixes my conception, allowing no after manipulation—the ultimate end, the print, is but a duplication of all that I saw and felt through my camera.

April 26, 1930

Someone reading over my statement questioned my use of the word "impressionism." To me it has always meant for example a tree momentarily shimmering in a brilliant sun or the same tree drenched, half hidden by a passing storm; painted, etched or photographed under such conditions—the transitory instead of the eternal.

But I don't want the play of sunlight to excite the fancy, nor the mystery of gloom to invoke the imagination —wearing colored glasses—I want the *greater mystery of things revealed more clearly than the eyes see,* at least more than the layman, the casual observer notes. I would have a microscope, shall have one some day.

On the other hand what a valuable way of recording just such passing moments is the camera! And I certainly would be the first to grasp the opportunity, if I were ready at the time! I can not, never have been bound by any theory or doctrine, not even my own.

Anything that excites me, for any reason, I will photograph: not searching for unusual subject matter but making the commonplace unusual, nor indulging in extraordinary technique to attract attention. Work only when desire to the point of necessity impels—then do it honestly. Then so called "composition" becomes a personal thing, to be developed along with technique, as a personal way of seeing.

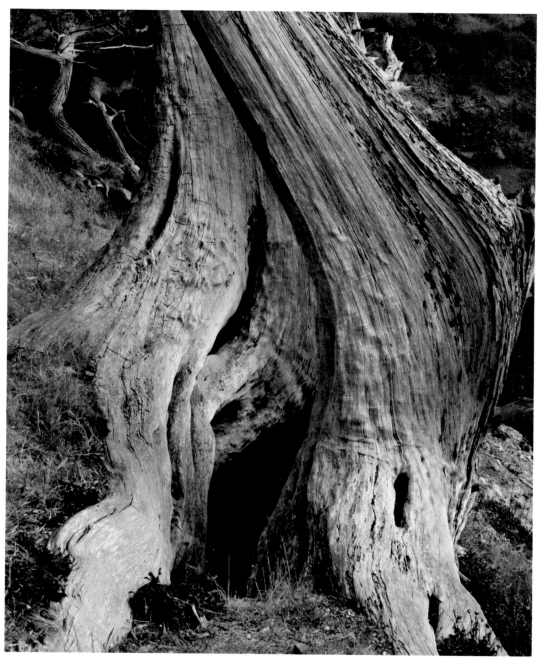

CYPRESS TRUNK Point Lobos 1930

January 28, 1932

No painter or sculptor can be wholly abstract. We cannot imagine forms not already existing in nature,—we know nothing else. Take the extreme abstractions of Brancusi: they are all based on natural forms. I have often been accused of imitating his work,—and I most assuredly admire, and may have been "inspired" by it,—which really means I have the same kind of (inner) eye, otherwise Rodin or Paul Manship might have influenced me! Actually I have proved, through photography, that Nature has all the "abstract" (simplified) forms, Brancusi or any other artist can imagine. With my camera I go direct to Brancusi's *source*. I find *ready to use,* select and isolate, what he has to "create."

But photography is not all seeing in the sense that the eyes see. Our vision, a binocular one, is in a continuous state of flux, while the camera captures and fixes forever (unless the damn prints fade!) a single, isolated, condition of the moment. Besides, we use lenses of various focal lengths to purposely exaggerate actual seeing, and we often "overcorrect" color for the same reason. In printing we carry on our willful distortion of fact by using contrasty papers which give results quite different from the scene or object as it was in nature.

This, we must agree is all legitimate procedure: but it is not "seeing" literally, it is done with a reason, with creative imagination.

I never try to limit myself by theories. I do not question right or wrong approach when I am interested or amazed,—impelled to work. I do not fear logic, I dare to be irrational, or really never consider whether I am or not. This keeps me fluid, open to fresh impulse, free from formulae: and precisely because I have no formulae—the public who know my work is often surprised, the critics, who all, or most of them, have their pet formulae are disturbed, and my friends distressed.

I would say to any artist,—don't be repressed in your work—dare to experiment—consider any urge—if in a new direction all the better—as a gift from the Gods not to be lightly denied by convention or *a priori* concept. Our time is becoming more and more bound by logic, absolute rationalism: this is a straitjacket!—it is the boredom and narrowness which rises directly from mediocre mass thinking.

The great scientist dares to differ from accepted "facts",—think irrationally—let the artist do likewise. And photographers, even those, or *especially* those, taking new or different paths should never become crystalized in the theories through which they advance. Let the eyes work from inside out—do not imitate "photographic painting", in a desire to be photographic!

Has this sounded like a sermon? I despise sermons, preachers, so I hope not. Perhaps I am really talking to myself. I have done some dangerous reasoning at times, but fortunately something beyond reason steps in to save me.

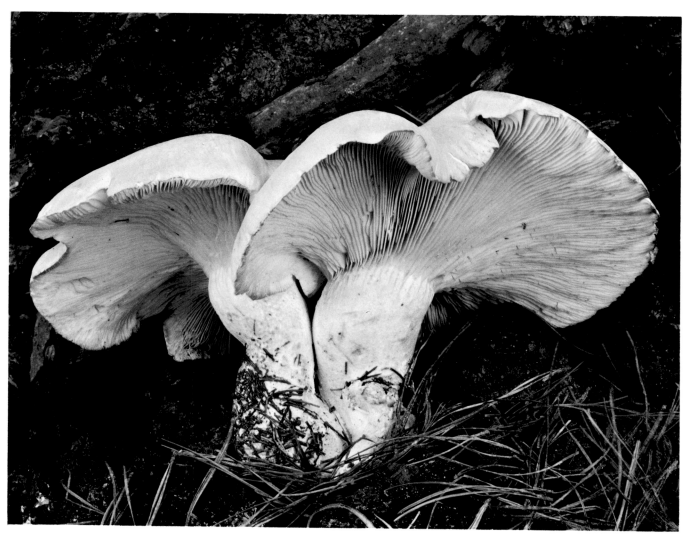

FUNGUS 1937

December 10, 1931 Carmel

I feel that I have been more deeply moved by music, literature, sculpture, painting, than I have by photography, that is by the other workers in my own medium. This needs explaining. I am not moved to emulate—neither to compete with nor imitate these other creative expressions, but seeing, hearing, reading something fine excites me to greater effort (*inspired* is just the word, but how it has been abused!). Reading about Stieglitz, for instance, meant more to me than seeing his work. Kandinsky, Brancusi, Van Gogh, El Greco, have given me fresh impetus: and of late Keyserling, Spengler, Melville (catholic taste!) in literature. I never hear Bach without deep enrichment—I almost feel he has been my greatest "influence." It is as though in taking to me these great conceptions of other workers, the fallow soil in my depths, emotionally stirred, receptive, has been fertilized.

Whenever I can feel a Bach fugue in my work I know I have arrived.

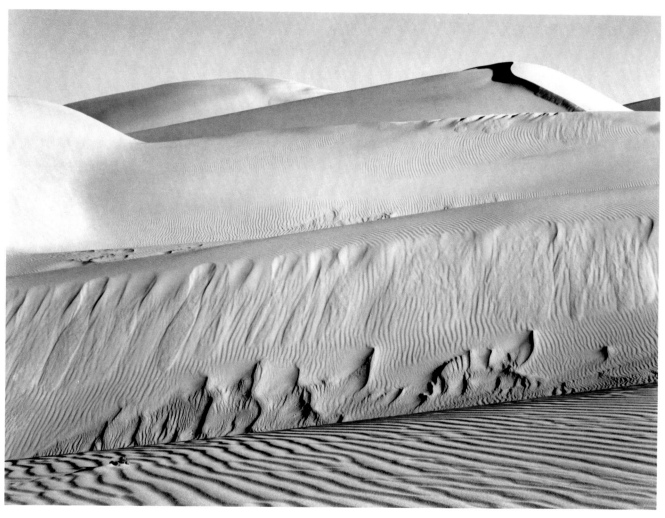

DUNES Oceano 1936

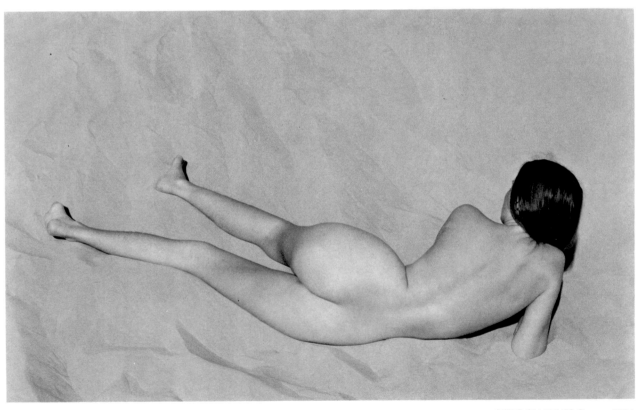

NUDE ON DUNES Oceano 1936

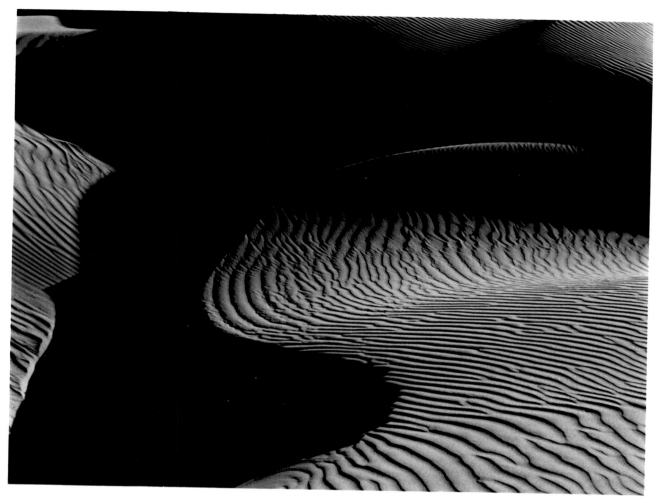

DUNES Oceano 1934

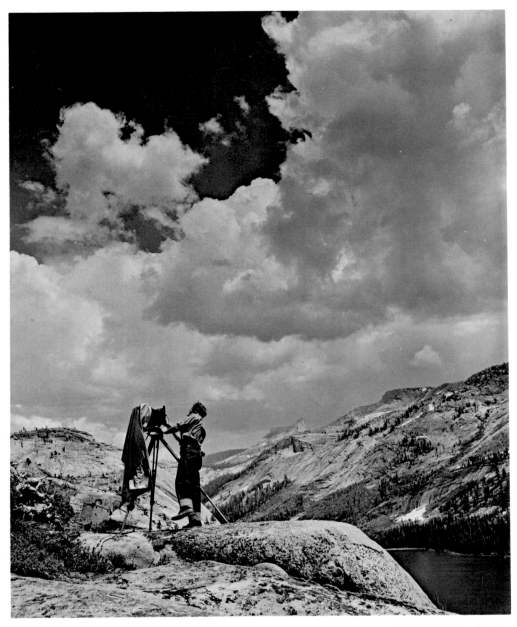

LAKE TENAYA Ansel Adams

I find myself every so often looking at my ground glass as though the unrecorded image might escape me!

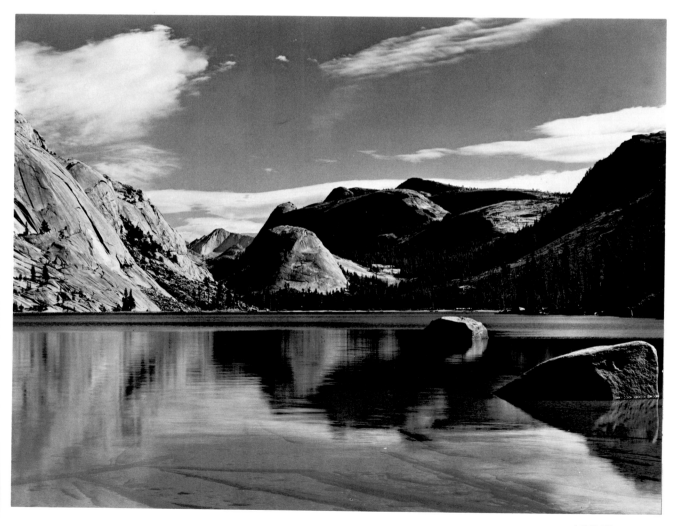

LAKE TENAYA 1937

February 23, 1932 Carmel

I am the adventurer on a voyage of discovery, ready to receive fresh impressions, eager for fresh horizons, not in the spirit of a militant conquerer to impose myself or my ideas, but to identify myself in, and unify with, whatever I am able to recognize as significantly part of me: the "me" of universal rhythms.

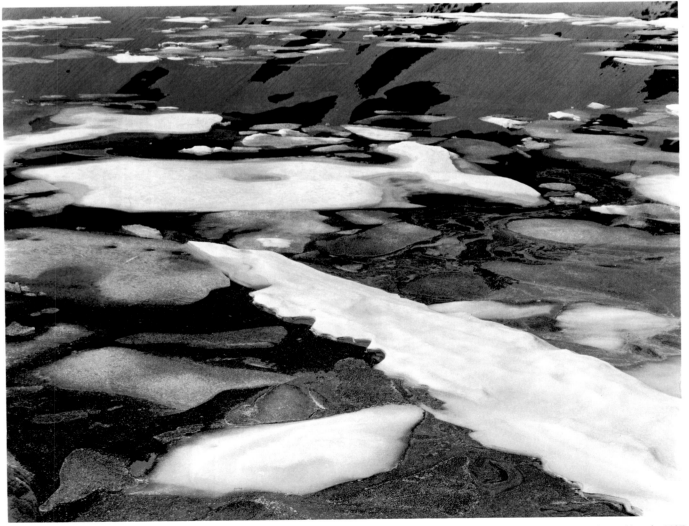

ICEBERG LAKE, Sierra Nevada 1937

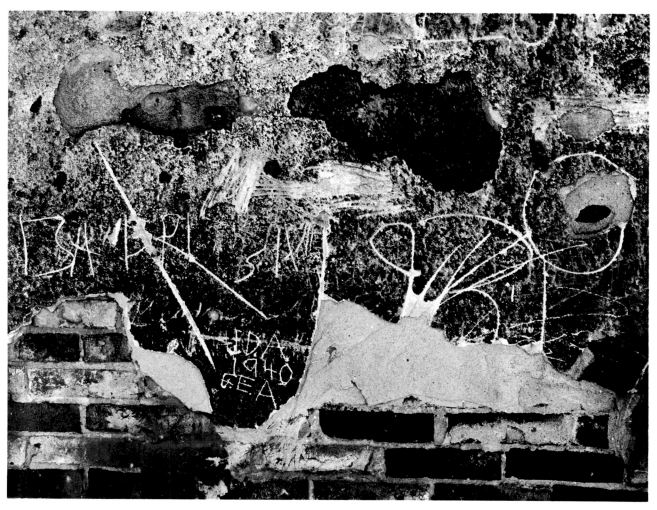

WALL SCRAWLS 1940

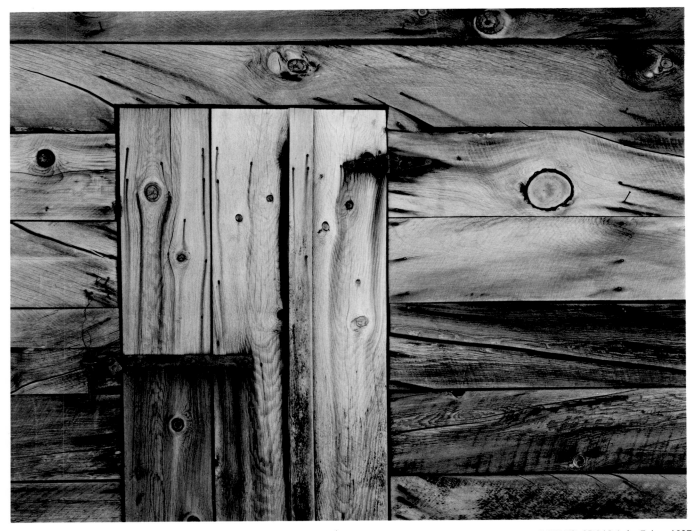

POTATO CELLAR Lake Tahoe 1937

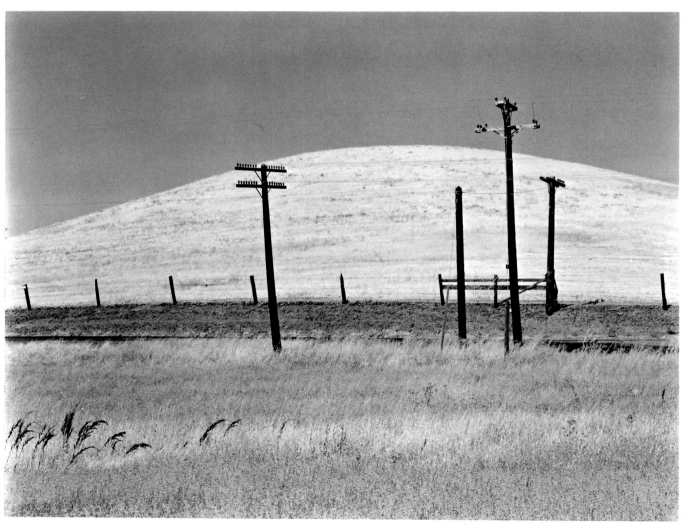

HILL AND TELEGRAPH POLES 1937

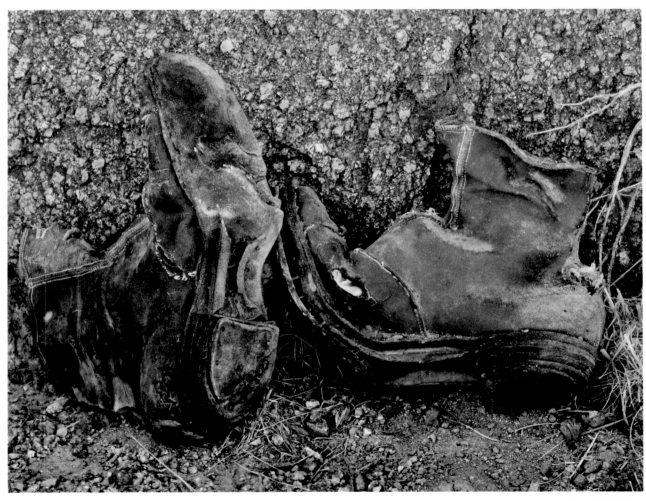

OLD SHOES 1937

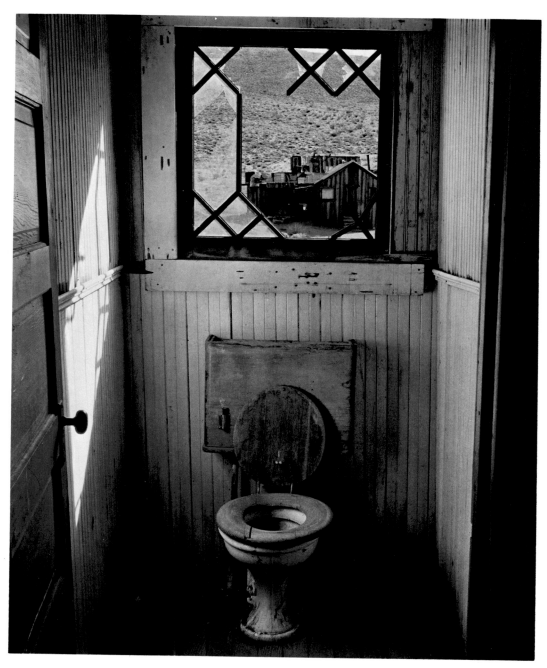

GOLDEN CIRCLE MINE 1939

57

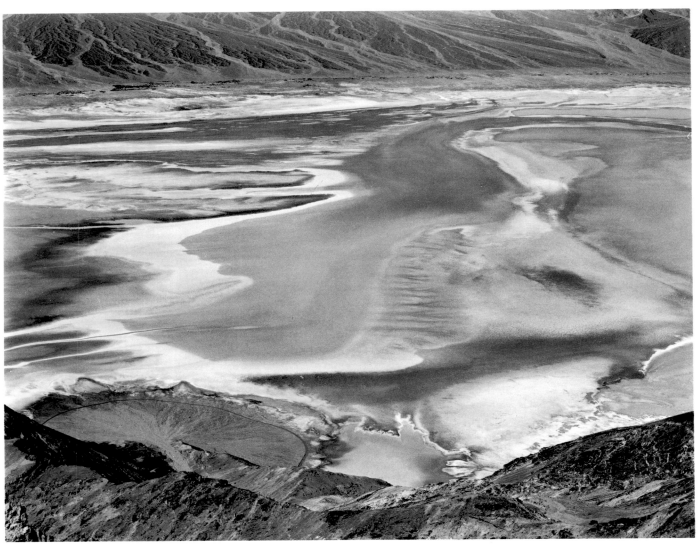

FLOOR OF DEATH VALLEY 1938

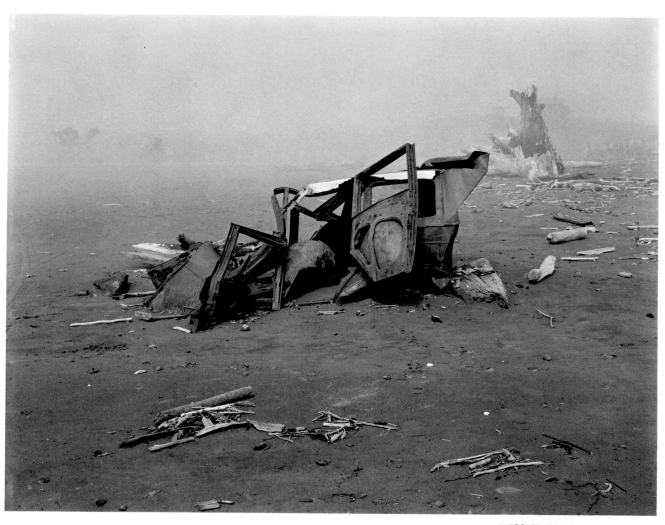

WRECKED CAR Crescent Beach 1939

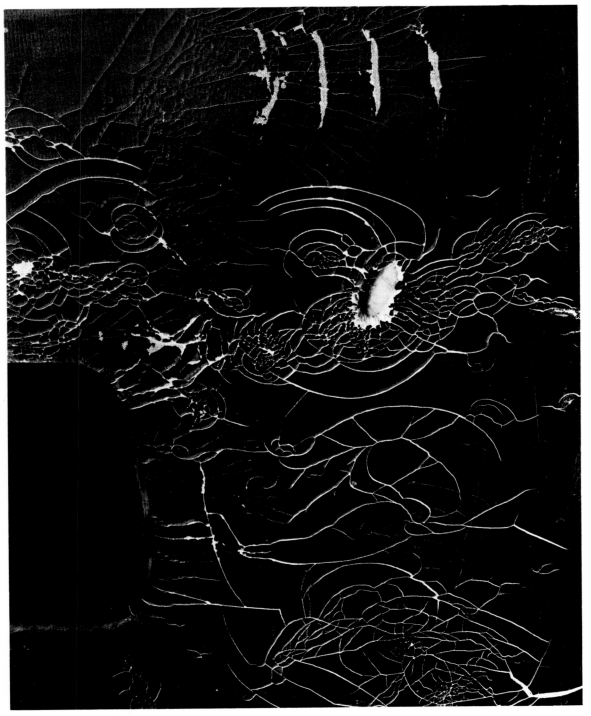

BURNED CAR Mojave Desert 1938

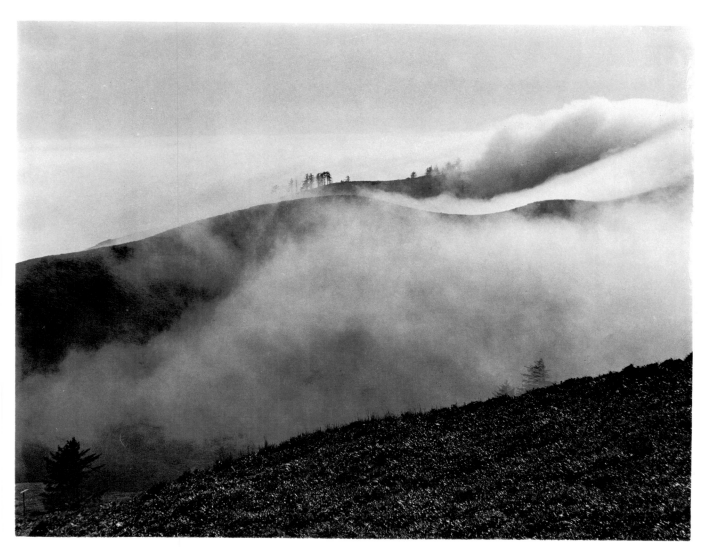

FOG Oregon Coast

I never answer published criticism, good or bad, about myself. I have found praise often just as wrong and more humiliating than disapproval.

I don't mind adverse or even abusive criticism, for I believe in my work, KNOW its importance, and know damn well where I am going without being told.

One difficulty in making any estimate of my work lies in the fact that I have done with a "period" ten years before it becomes popular. Another is that when exhibiting I usually select everything from one period—that which interests me most: the present.

My "faces and postures" period, my heroics of social significance, were done about 1923: the head of the revolutionary Galván, General under Villa, Guadalupe orating (or ranting), head of the cement worker, head of Nahui Olin (psychological) etc.

My industrial period was over by 1922. My façades, ("Immobile surfaces") were done in Mexico from 1925-27 (when I was accused of being in N. Y. copying another photographer's work). A large collection of pulquerias (only two ever printed for myself) and done before I ever heard of Atget. In this latter period are included interiors of peons' huts and tenement houses.

And what does anyone know of my past year's work? 1300 negatives,—21,000 miles of searching. No, I have not done "faces and postures," except one dead man (wish I could have found more) and many dead animals; but I have done ruins and wreckage by the square mile and square inch, and some satires.

It seems so utterly naive that landscape—not that of the pictorial school—is not considered of "social significance" when it has a far more important bearing on the human race of a given locale than excrescences called cities. By landscape, I mean every physical aspect of a given region—weather, soil, wildflowers, mountain peaks —and its effect on the psyche and physical appearance of the people. My landscapes of the past year are years in advance of any I have done before or any I have seen.

I have profound interest in anyone who is doing a fine job of·photographing the "strident headlines," but to point it as the only way in which photography can be "faithful to its potentialities" is utter rot. There are as many ways to see and *do* as there are individuals—and there are far too few of them.

Atget was a great documentary photographer but is misclassed as anything else. The emotion derived from his work is largely that of connotations from subject matter. I have a deep respect for Atget: he did a certain work well. I am doing something quite different.

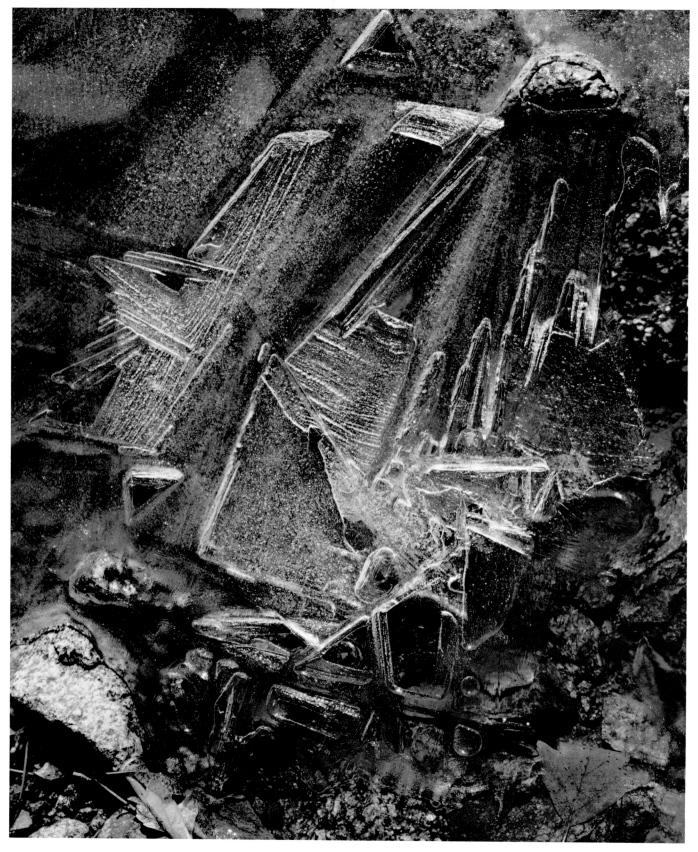

MELTING ICE 1938

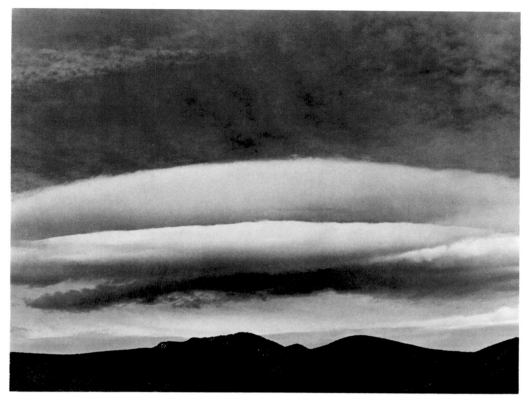

CLOUD OVER THE PANAMINTS Death Valley 1937

The painters have no copyright on modern art! . . . I believe in, and make no apologies for, photography: it is the most important graphic medium of our day. It does not have to be, indeed cannot be—compared to painting —it has different means and aims.

[*When the article title,* Edward Weston, Artist *was sent to him in galley, he circled the word "Artist" with the comment: "Cut, or change to 'Photographer,' of which title I am very proud."*]

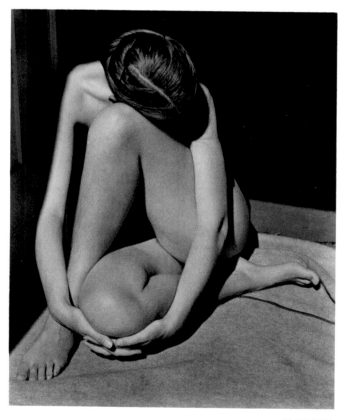

NUDE 1936

December 24, 1940

I have thought of you often these last few days because you loved our coast. We have had a real storm and high sea with promise of a wet Christmas. I wanted you to see the Pacific (misnamed) this way, with tremendous breakers that shake our house and wind driving horizontally. And the hills are turning green now, the first wild flowers out.

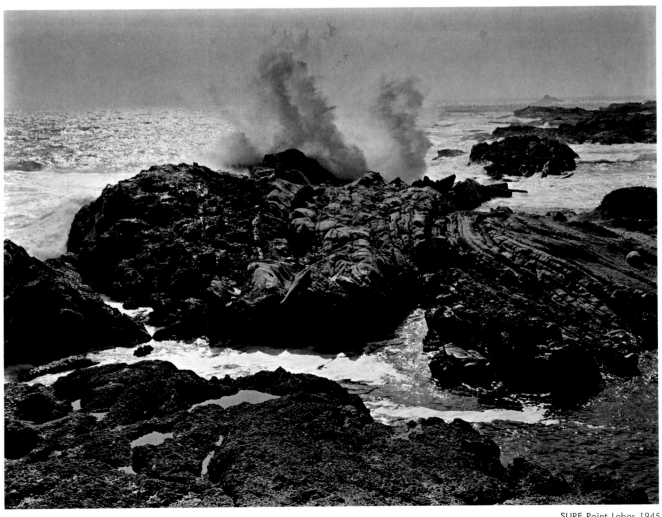

SURF Point Lobos 1945

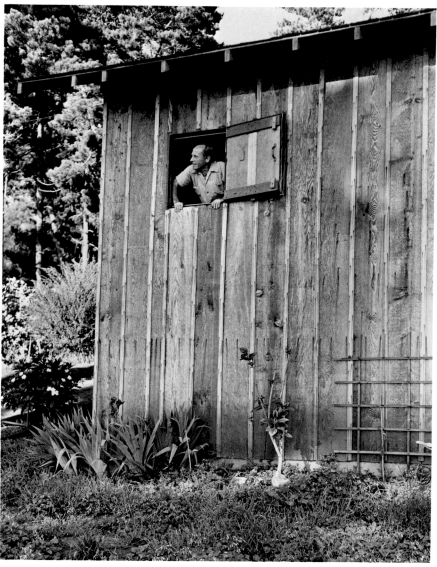

THE DARKROOM WINDOW Carmel 1940 Photograph by Beaumont Newhall

During World War II, Weston served as an airplane spotter on Yankee Pt., a high headland above the Pacific.

Just down from my 6:00 watch, A. W. S.; a beautiful dawn with scattered showers and rainbows. The rains were late this year, but plentiful by now, and the spring flowers as a result are especially fine — zigadine (spell?) wild iris, wild currant, solomon seal, oxalis, many more.

Here are a few of them — better than words to say that I miss you both....

The ack-ack is deafening today.

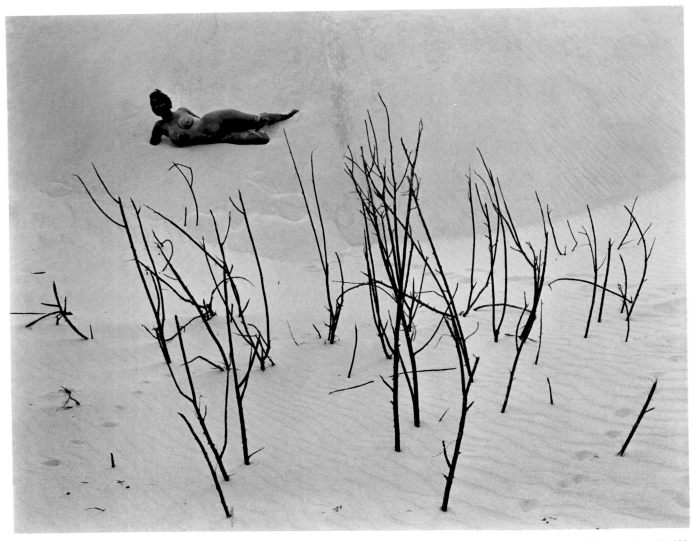

NUDE ON DUNES 1939

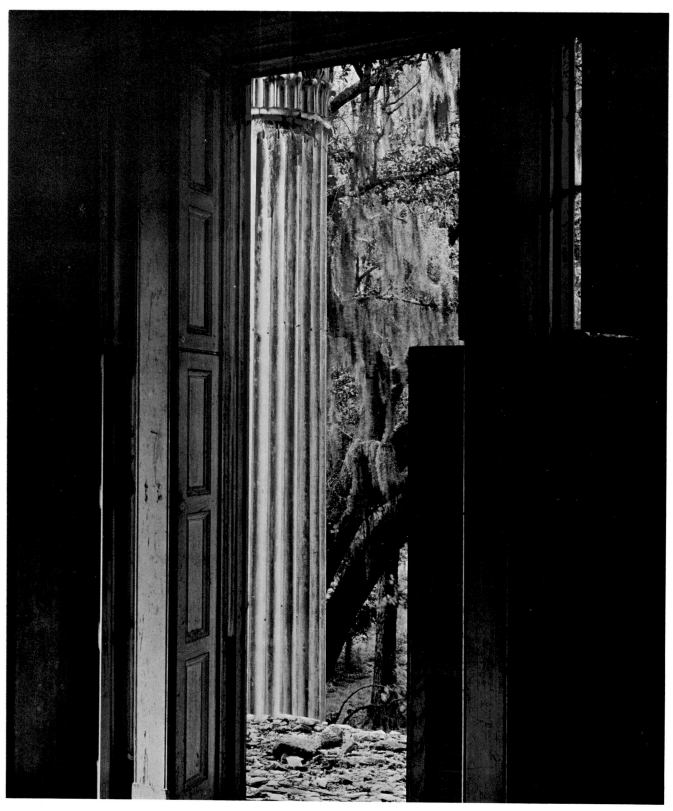

BELLE GROVE, Louisiana 1941

On accepting a commission to illustrate Walt Whitman's LEAVES OF GRASS

April 28, 1941

I have thought over the subject pro and con, questioned "am I the one to do this?" This I should tell you; there will be no attempt to "illustrate," no symbolism except perhaps in a very broad sense, no effort to recapture Whitman's day. The reproductions, only 54, will have no titles, no captions. This leaves me great freedom— I can use anything from an airplane to a longshoreman. I do believe, with Guggenheim experience, I can and will do the best work of my life. Of course I will never please everyone with *my* America—wouldn't try to.

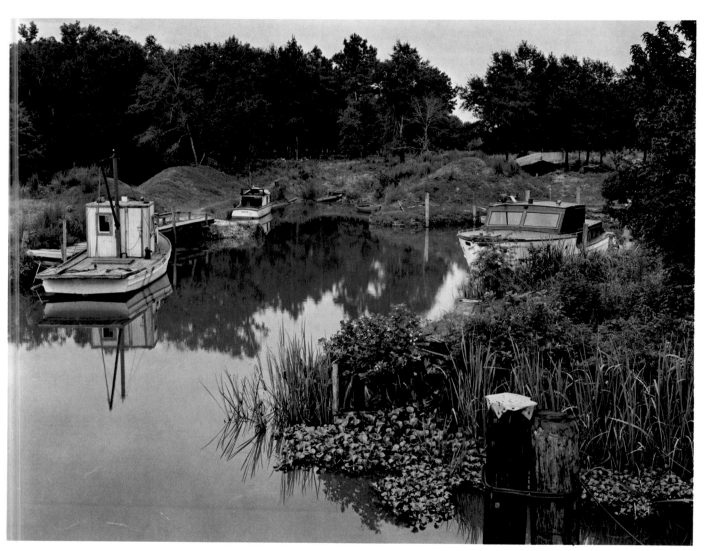

BAYOU, Louisiana 1941

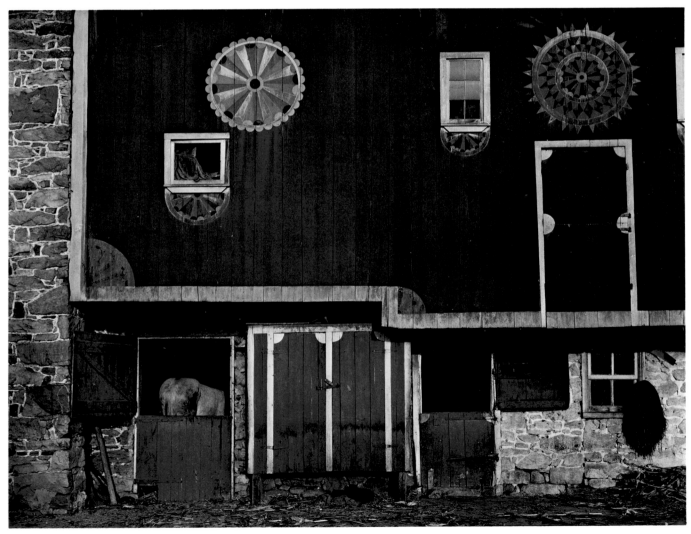

PENNSYLVANIA DUTCH BARN 1941

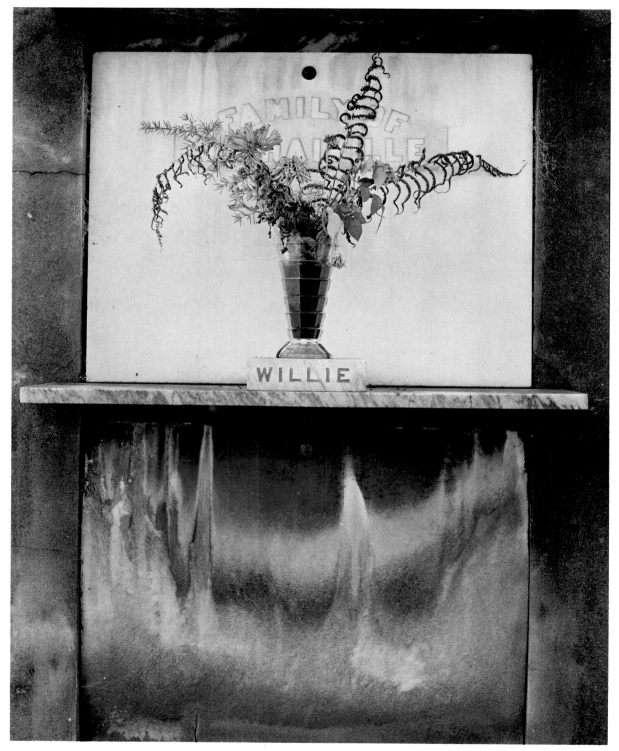

WILLIE New Orleans 1941

JEAN CHARLOT AND WIFE 1933

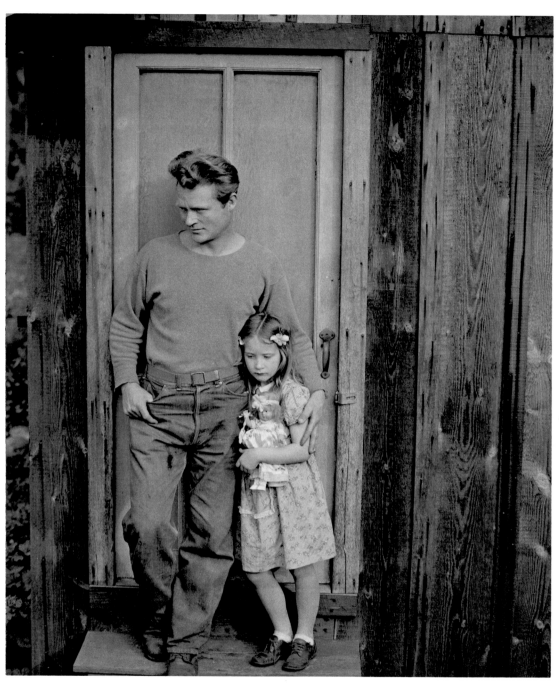

BRETT AND ERICA WESTON 1945

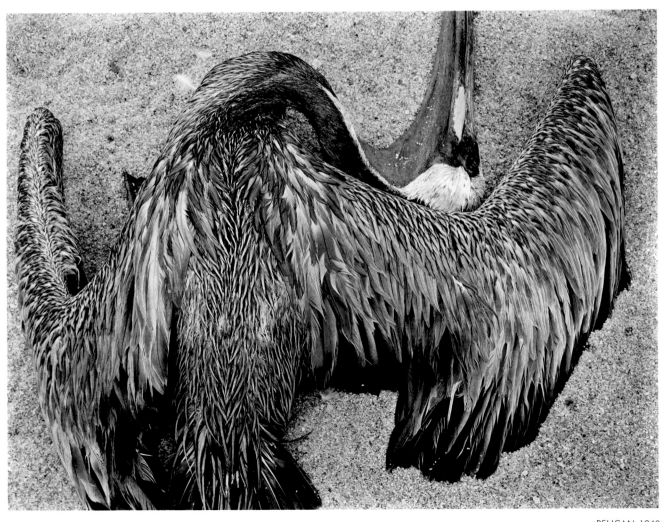

PELICAN 1942

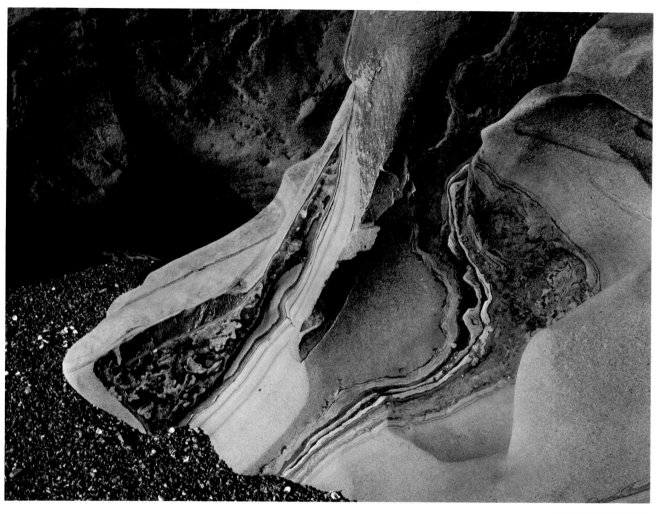

POINT LOBOS 1930

During World War II

Since travel is out, and Point Lobos is closed, I have taken to portraits with backgrounds. For example: Neil against garage door with black interior to left spotted with streaks of light from batten-less wall and an open door in the distance through which flowers are framed. Another! Cole squats whittling a stick; he is in brilliant sun from a hole in the pine which shades the rest of the picture; the background is pine logs end on. And there is a good nude in the same manner: figure in window back of screen (I am outside with camera); figure very classic, pine boards very rough; on the exposed plumbing sit a couple of battered shoes Neil mailed from the desert; chimney on one side, vine covered and fuchsia in opposite corner.

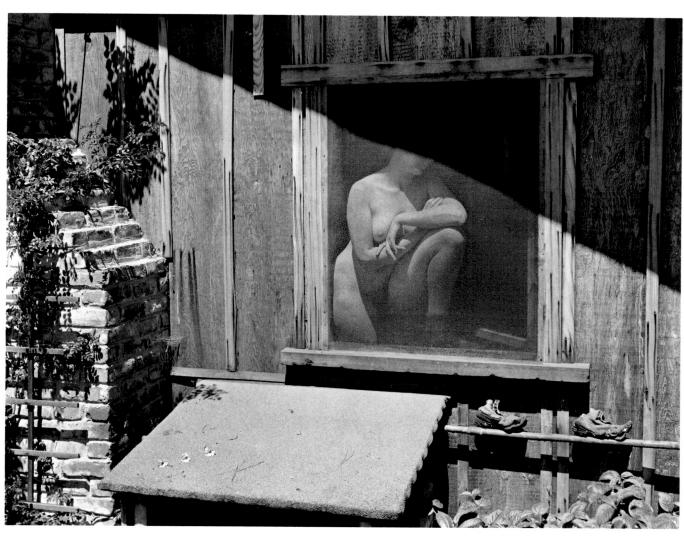

SPRING 1943

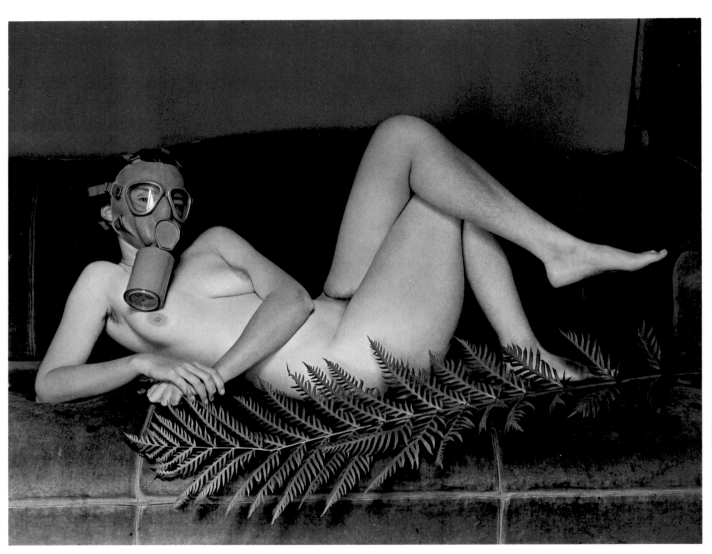

CIVILIAN DEFENSE 1942

January 1, 1944 Wildcat Hill

Sorry to have upset you with my "backyard set-ups and their titles." You guess that the war has upset me. I don't think so, not more than the average dislocation. I am much more bothered by the antics of some Congressmen and women, or by radio "commercials." As to Pt. Lobos, it has been open to the public for months, but I have had no desire to work there. No, darling, don't try to pin pathology on me.

Your reaction follows a pattern which I should be used to by now. Every time that I change subject matter, or viewpoint, a howl goes up from some Weston fans. An example: in the E. W. Book (Weyhe) is a reproduction of "Shell & Rock—Arrangement"; my closest friend, Ramiel, never forgave me for putting it in the book because it was "not a Weston."

And finally (I could go on for pages) when I turned from shells, peppers, rocks—so-called abstract forms, Merle Armitage called my new direction the "hearts & flowers" series.

So I am not exactly surprised to have you condemn (though I don't get your "Surrealist" classification) work which will go down in history . . . great photographs on which I will stake my reputation. I could go on, but you might think me defensive. I could explain my titles (I really had fun tacking them on AFTER "creation") but surely explanation would insult you.

September 21, 1943 Wildcat Hill

Of course I *meant* to confound you with the titles to my new photographs (even titling is a departure for me—but such titles). I don't think I told you my latest: "Exposition of Dynamic Symmetry." It contains four figures.

March 1, 1944 Wildcat Hill

Can anyone say where and when the "Pictorialist" & "Purist" part ways? Can anyone be worse than a puritanical Purist! I can honestly say that I never based my way of seeing on moral grounds. I just think—today—that there is nothing so beautiful as a sharp, long scale, glossy photograph. But tomorrow? I have a sneaking suspicion that someday I'll throw my "fans" into utter confusion by making a series of soft focus negatives, just to contradict myself and say "it can be done."

On selecting for his retrospective exhibition at the Museum of Modern Art, 1946

August, 1945

Ansel does not agree with me in hanging old "historical" work. (Only the best you have ever done, only examples of the photography you believe in should be shown.) Well then I say, why a retrospective at all? I think a presentation of one's growth of interest & importance—even early corn—

I will also be criticized for the size of my show. But I am a prolific, mass-production, omnivorous seeker. I can't be represented by 100, 200, or even 300 photographs to cover 44 years work. By the way 2% of my show made last month! Not printed but *photographed.* Well if public can't *see* 300 photographs [during one visit to the exhibition] let them come again and again and again.

82

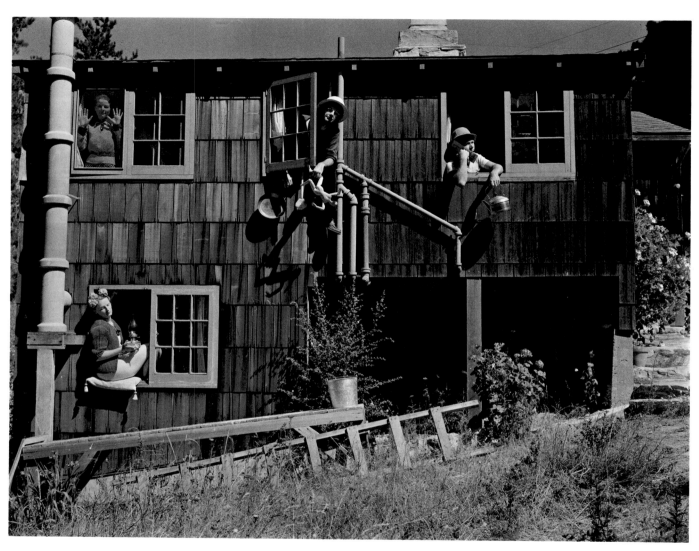

DYNAMIC SYMMETRY 1943

On photographing nudes
…without any instructions to the models (I never use professionals, just my friends) as to what they should do, I would say, "Move around all you wish to, the more the better." Then when something happened, I would say, "Hold it." And things did happen all the time. I would often use a magazine of 18 in an hour or less.

March 3, 1945
Work and Play in Progress, I made some new negatives, one called "Nude and Blimp", another "Winter Idyll." Pure succotash. They will go in Museum of Modern Art Show.

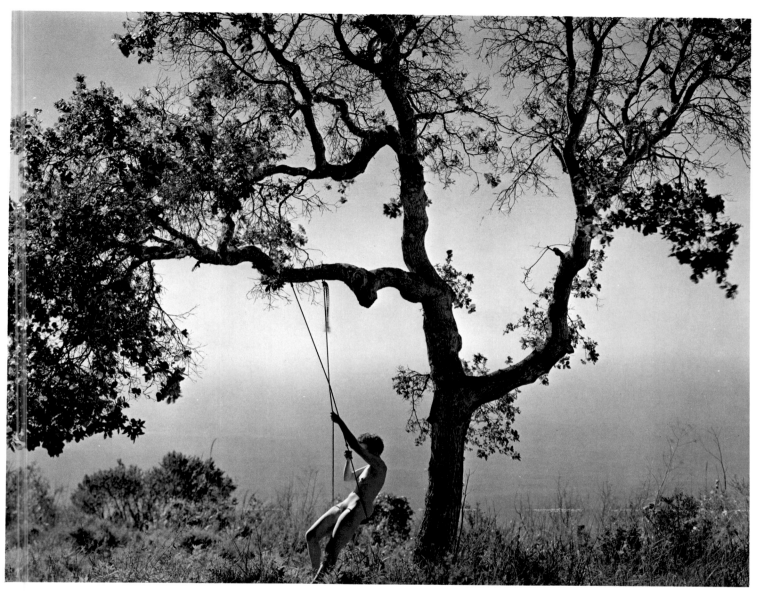

WINTER IDYLL the Big Sur 1945

April 24, 1930
I start with no preconceived idea—
discovery excites me to focus—
then rediscovery through the lens—
final form of presentation seen on ground glass,
the finished print previsioned complete in every
detail of texture, movement, proportion,
before exposure—
the shutter's release automatically and finally
fixes my conception, allowing no after manipulation—
the ultimate end, the print, is but a duplication
of all that I saw and felt through my camera.

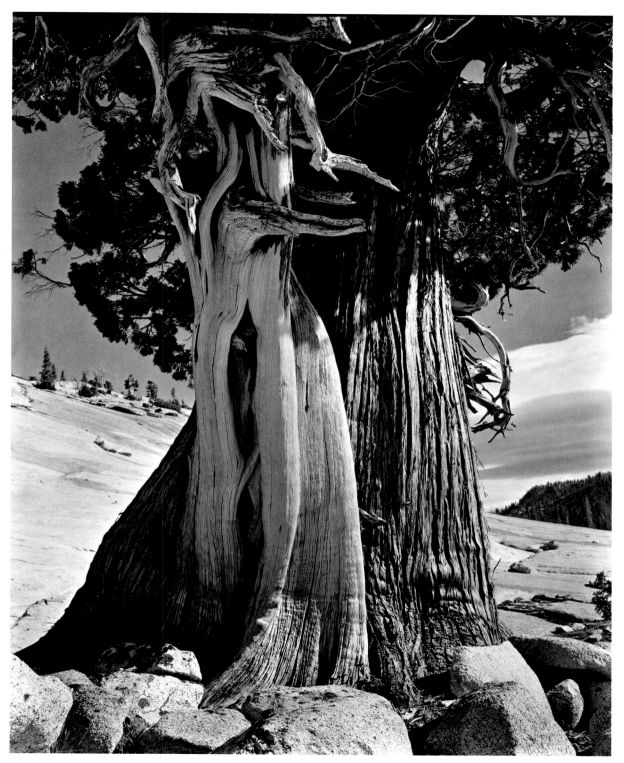

JUNIPER Lake Tenaya 1938

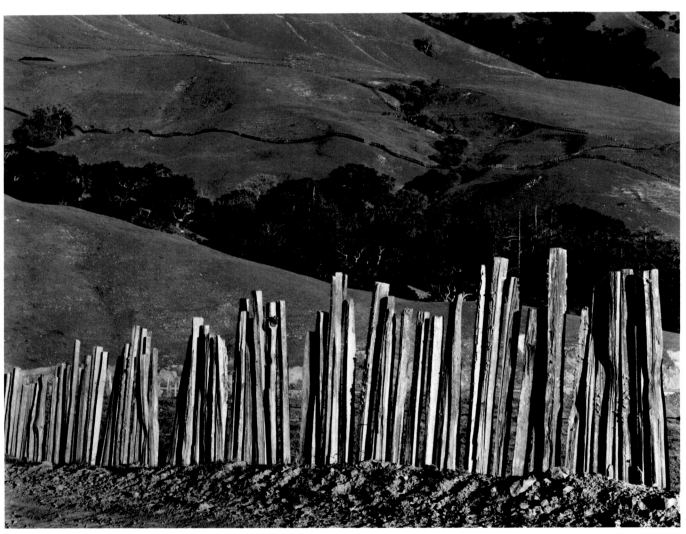

OLD BIG SUR ROAD 193?

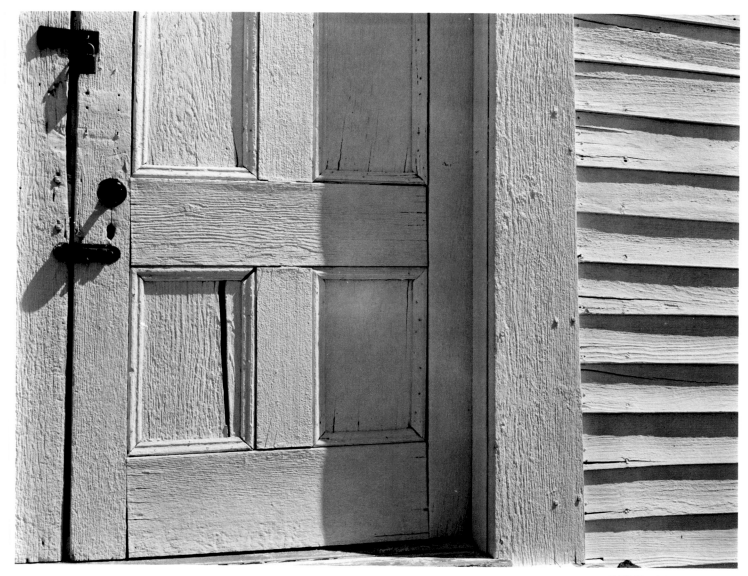

CHURCH DOOR Hornitos 1940

November, 1946
To all critics, pro or con — my work or anyone's work — in photography, painting, sculpture or music, I say (digo yo) you can't explain a Bach fugue. If you could you would explain away its very meaning — its reason for existence.

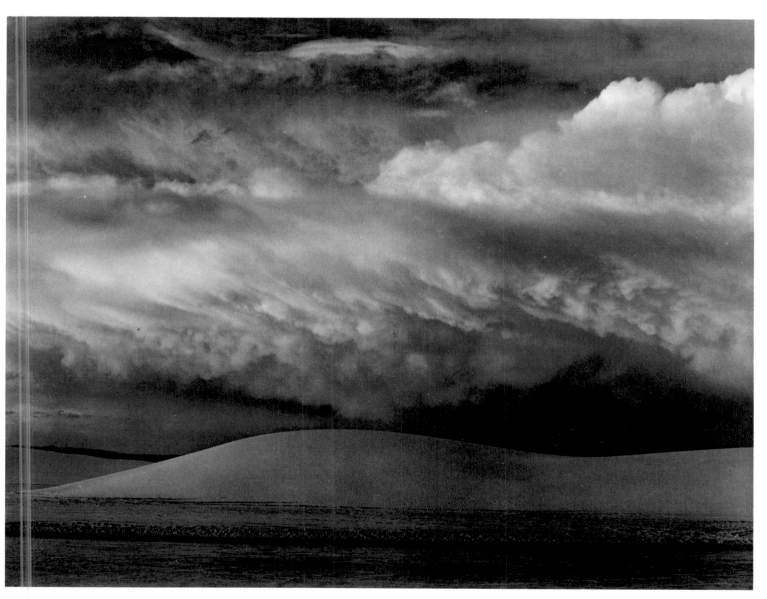

WHITE SANDS New Mexico 1941

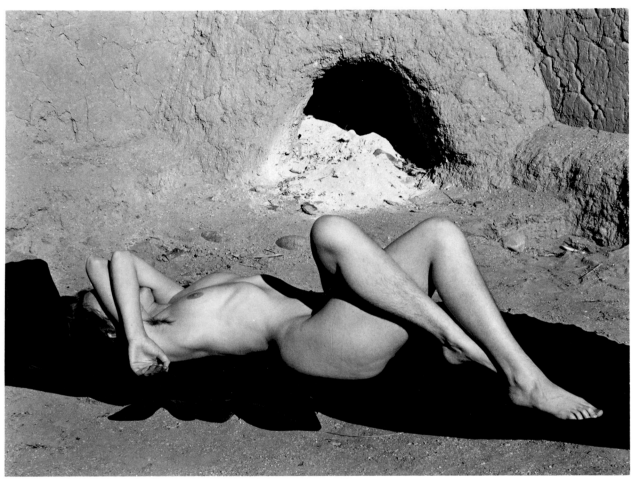

NUDE AND OVEN New Mexico 1941

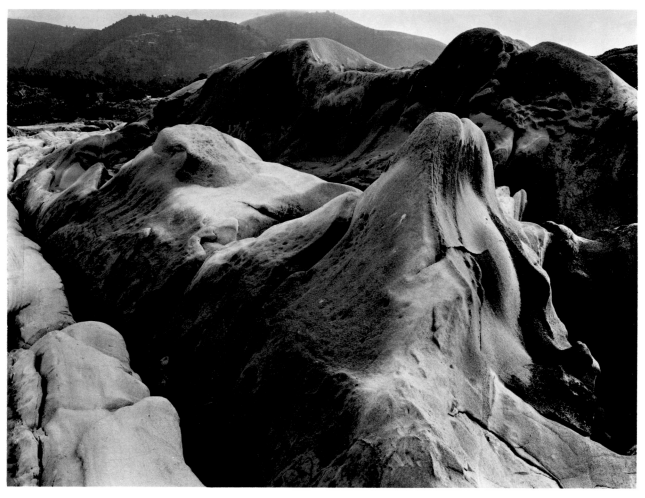

SOUTH SHORE Point Lobos 1938

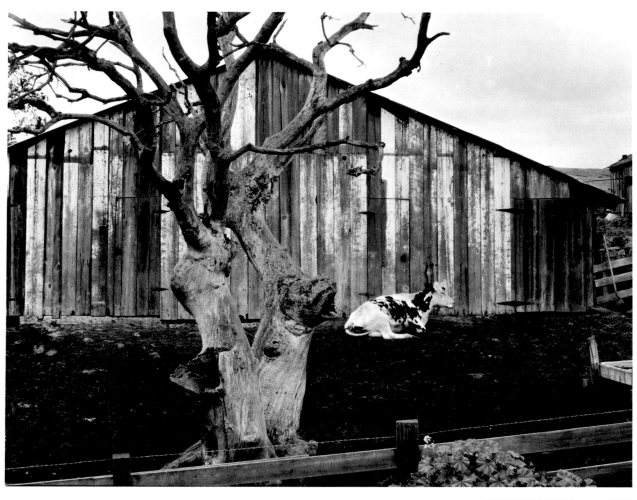

COW, TREE, BARN Monterey 1933?

December 1946
As for Death as a theme—it certainly didn't start with the deadman in the Colorado desert. Before 1920 I did skulls and dead Joshua trees on the Mohave desert. But then—as now—death was not a theme—it was just part of life—as simple as that.

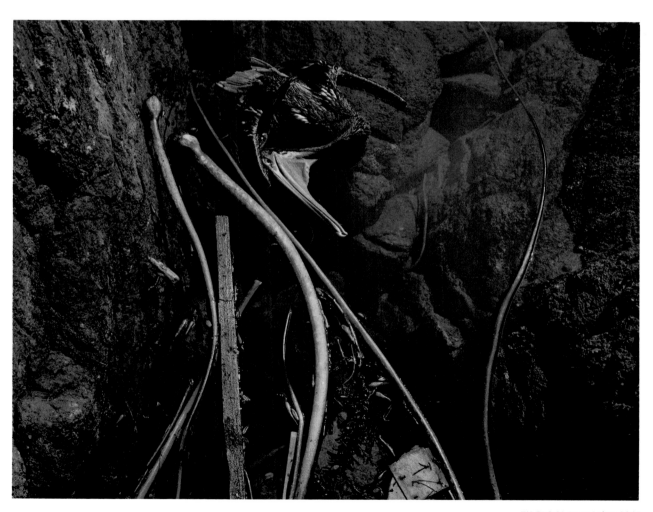

TIDEPOOL Point Lobos 1945

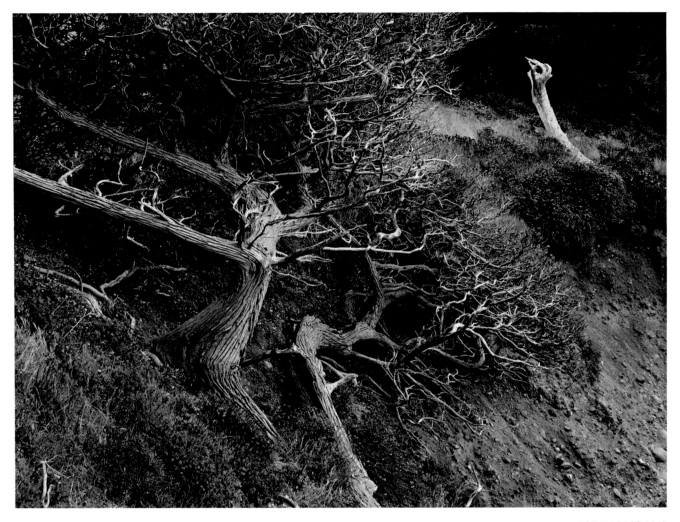

POINT LOBOS 1948

Letter: 1948, probably May Wildcat Hill

Whatever has happened to me, I've brought on myself, and only I can lift myself out of the abyss.

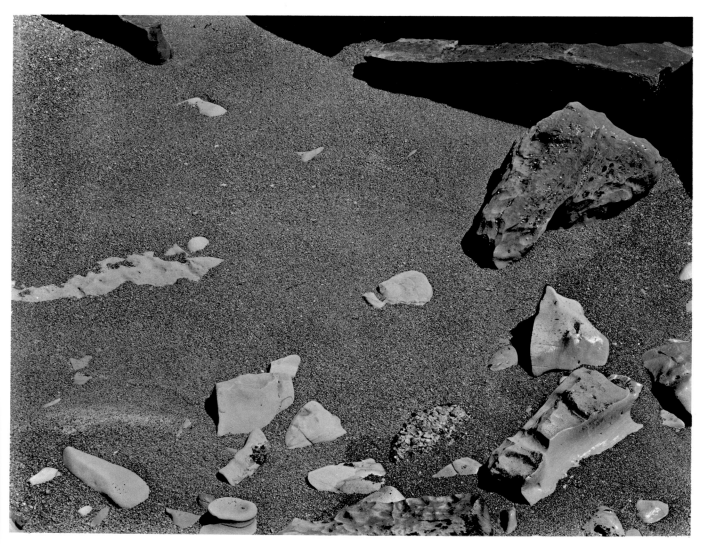

POINT LOBOS 1948

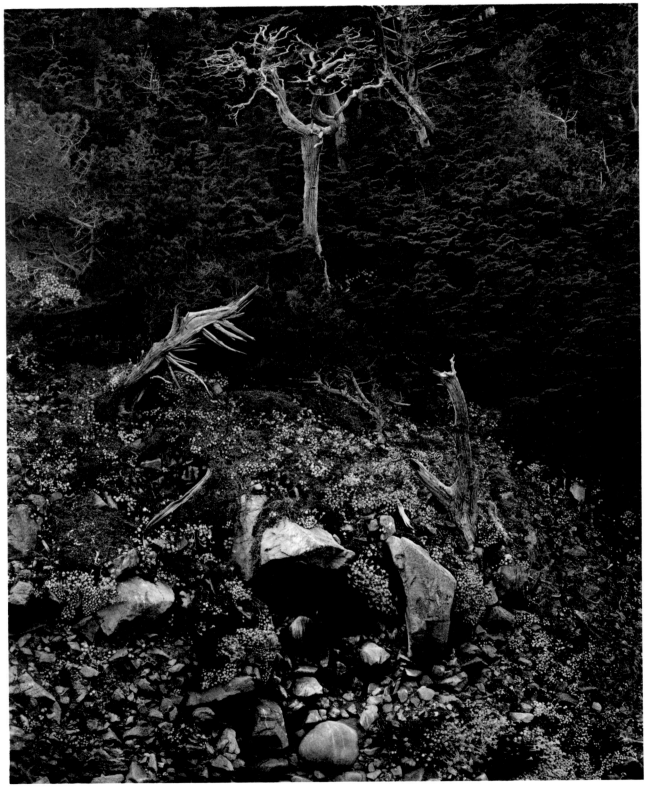

NORTH WALL Point Lobos 1946

Letter: March 28th, 1954 Wildcat Hill
Robin once wrote "You are safe to finish what you have to finish." **Maybe** he is right, in fact I'm sure he is. So thinking, I wonder how that thought touches me. Was I cut off from my creative work at just the right time? Was I through? I don't think so, but could be.

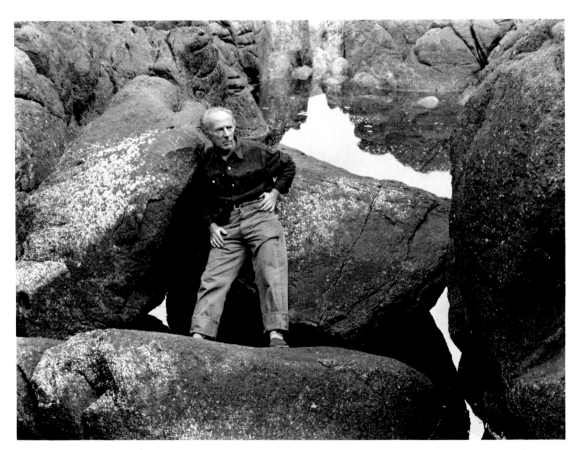

Photograph by Cole Weston

Minor White:

Rarely are we shown the maturest work of men who have lived richly and whose spirit has grown all their lives . . . the last photographs Edward Weston made at Point Lobos . . . may parallel in content the last quartets of Beethoven.

Robinson Jeffers:

Weston's life and his work are . . . simple, effective, and without ceremony. . . . He was one of those who taught photography to be itself.

Jean Charlot:

Under the stupendous concentration of the artist's mind, 1/35 of a second suffices to create an image with which to perpetuate his spiritual passion.

Merle Armitage:

The work of Edward Weston has made a great contribution to American Art. . . . I am one among a large and constantly growing audience for whom Edward Weston has changed the world.

Beaumont and Nancy Newhall:

To Edward, who gave us a new focus and a new horizon, part of everything we have done and shall yet do, belongs.

Ansel Adams:

Weston is, in the real sense, one of the few great creative artists of today. He has recreated the mother-forms and forces of nature; he has made these forms eloquent of the fundamental unity of the world. His work illuminates man's journey toward perfection of the spirit.

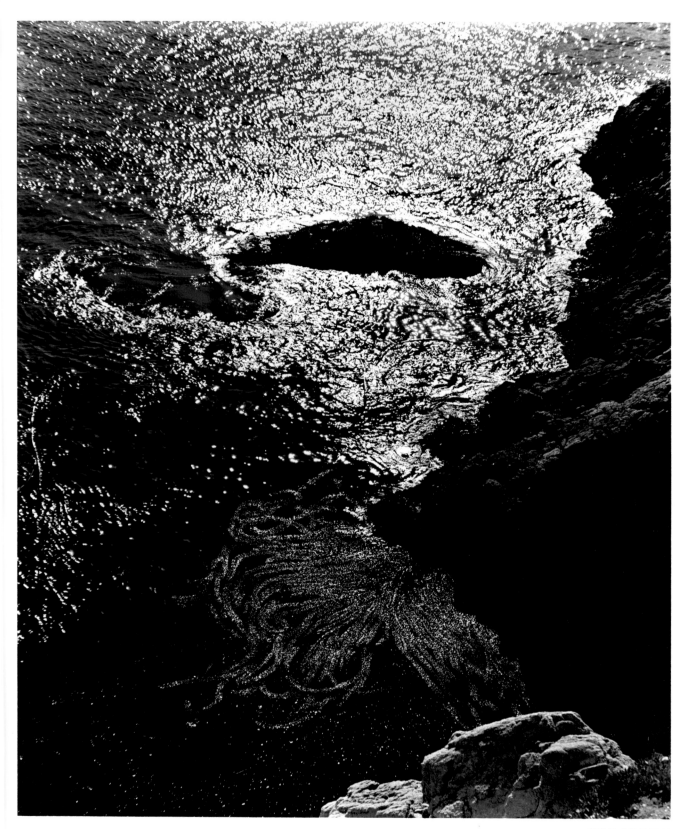

CHINA COVE 1940

Brief Bibliography and Guide to the Work of Edward Weston

Books:

1932 Armitage, Merle, editor and designer THE ART OF EDWARD WESTON New York: E. Weyhe. 39 fine reproductions in halftone. Tributes by Armitage, Charles Sheeler, Robinson Jeffers, Jean Charlot; statement by Weston. First book presentation of Weston's work. Produced in the middle of the Depression in four months; voted one of the Fifty Best Books of the Year by the American Institute of Graphic Arts.

1934 Weston, Edward PHOTOGRAPHY Pasadena: Esto Publishing Co. (Enjoy Your Museum series) Weston's philosophy and technique simply and strongly stated in a pamphlet now rare and hard to find.

1940 Weston, Edward and Charis Wilson Weston CALIFORNIA AND THE WEST New York: Duell, Sloan and Pearce. 96 reproductions. Charis, Edward's second wife, kept a log during their journeys on his Guggenheim Fellowship; interesting eyewitness account.

1942 Whitman, Walt LEAVES OF GRASS Introduction by Mark Van Doren and photographs made by Edward Weston for the Limited Editions Club, New York. 2 vols. Frontispiece and 50 plates. Very rare. Contain photographs never exhibited nor reproduced elsewhere.

1946 Newhall, Nancy THE PHOTOGRAPHS OF EDWARD WESTON New York: The Museum of Modern Art. Monograph accompanying Weston's first major retrospective exhibition. Biographical chronology, list of exhibitions, bibliography. 24 plates.

1947 Armitage, Merle, editor, designer FIFTY PHOTOGRAPHS: EDWARD WESTON New York: Duell, Sloan and Pearce. Introductions by Armitage, Donald Bear, Robinson Jeffers; statement by Weston. Again one of the Fifty Best Books of the Year.

 Weston, Edward and Charis Wilson Weston THE CATS OF WILDCAT HILL New York: Duell, Sloan and Pearce. 19 reproductions. Astonishing technical feat—cats photographed with an 8 x 10 camera.

1950 Adams, Ansel, editor EDWARD WESTON MY CAMERA ON POINT LOBOS Yosemite: Virginia Adams and Boston: Houghton Mifflin Co. Essay on Point Lobos by Dody; excerpts from Weston's *Daybook* concerning Point Lobos; technical note by Adams. 30 magnificent halftones, watched through the press by Adams. Rare.

1952 Newhall, Nancy EDWARD WESTON AND THE NUDE *Modern Photography*, June. The importance of the Nude to Weston and the development of his approach to it as a recurring theme through forty years of work.

1961 THE DAYBOOKS OF EDWARD WESTON Vol. I: *Mexico* Rochester: The George Eastman House. Edited, with biographical introduction, by Nancy Newhall. Foreword and Technical Note by Beaumont Newhall. 40 plates, showing Weston's growth from 1916 Pictorial Salon winner to creative artist hailed by his peers in any medium. Intimate and revealing record, basic to an understanding of Weston and of photography in the 1920s. Bibliography, index.

1966 THE DAYBOOKS OF EDWARD WESTON Vol. II: *California* 1927-1934. New York: Horizon Press, in Collaboration with The George Eastman House. Edited by Nancy Newhall. 40 plates. The last entry of the Daybooks, dated December 9, 1934, followed by a resumé dated April 22, 1944 of Weston's life with Charis Wilson Weston, whom he married in 1939.

1969 Weston, Cole EDWARD WESTON: DEDICATED TO SIMPLICITY *Modern Photography*, May. A son's gradually increasing understanding of his father. Accurate, moving, and vivid.

Articles:

1930 Weston, Edward "Photography—Not Pictorial" *Camera Craft*, v. XXXVII, July, p. 313-20. One of the statements that led to the formation of Group f/64.

1939-1943 Weston, Edward (with Charis Wilson Weston) Series of articles actually written by Charis which express his mature approach to his medium.

 Camera Craft, 1939: "What Is Photographic Beauty?" v. XLVI, p. 247-55; "What Is a Purist?", ibid, p. 3-9; "Thirty-five Years of Portraiture" ibid, p. 399-408, 449-60; "Photographing California" ibid, p. 56-64, 99-105; "Light vs. Lighting" ibid, p. 197-205.

 U.S. Camera Annual 1940 "Of the West: A Guggenheim Portrait" p. 37-55, Sketch for CALIFORNIA AND THE WEST.

 Encyclopaedia Britannica, 1941 and subsequent editions "Photographic Art" (revised for 1954 edition by Beaumont Newhall).

 Complete Photographer 1942; "Portrait Photography" v. VIII, December, p. 2935-40. 1943: "Seeing Photographically" ibid, v. IX, January, p. 3200-206.

1946 Newhall, Beaumont "Edward Weston in Retrospect" *Popular Photography*, v. XVIII, March, p. 42-46, 142, 144, 146. What it was like to photograph, develop and print with Weston.

1953 Weston, Edward (as dictated to Nancy Newhall) "Color as Form" *Modern Photography*, v. XVII, December. Weston's approach to color photography. Important.

1958 Maloney, Tom "Edward Weston, Master Photographer, 1886-1958" *U.S. Camera*, v. 21, p. 66-68, May. Maloney reminisces on how he and Steichen helped Weston get the first Guggenheim to be awarded to a photographer; how he met Weston through Ansel Adams; how he helped in the publication of CALIFORNIA AND THE WEST.

 Parella, Lew, editor "Special Weston Issue" of the Swiss Magazine, *Camera* (Lucerne), v. XXXVII, April, p. 147-181.

 Newhall, Beaumont and Nancy MASTERS OF PHOTOGRAPHY New York: Braziller. Brief biography and 15 reproductions; Weston among his peers and contemporaries. Note on techniques by Beaumont Newhall; bibliography, index.

1962 Adams, Ansel "Review of the DAYBOOKS OF ED-WARD WESTON" *Contemporary Photographer,* winter, p. 44-48. Perceptive and affectionate statement by an old friend and fellow fighter.

Original Prints:

Most museums and universities of major stature possess collections of Weston's work; consult the Print Room or the Department of Photography. Among these are: The Museum of Modern Art, New York; The George Eastman House, Rochester, N. Y.; The Art Institute of Chicago; The Henry E. Huntingdon Library, San Marino, California; the Amon Carter Museum, Fort Worth, Texas. Many other museums and private collectors possess:

1952 FIFTIETH ANNIVERSARY PORTFOLIO. Foreword by Weston printed by the Grabhorn Press, San Francisco, 12 prints made under Weston's supervision by his second son, Brett.

The Museum of Modern Art and The Art Institute of Chicago both have complete sets of:

1955 MASTER FILE Thanks to donors who wish to remain anonymous. Weston selected from his life work nearly a thousand negatives he considered his best. Printed under his supervision by Brett, organized and presented by Dody. Eight sets printed.

Motion Pictures:

1948 THE PHOTOGRAPHER The United States Information Agency. Directed by Willard Van Dyke. Commentary written by Irving Jacoby. Film editor Alexander Hammid. Van Dyke, a former student, fellow founder of Group f/64, and close friend, photographed Weston in his Carmel home, on Point Lobos, printing in his darkroom; revisited with him Death Valley, Lake Tenaya, the ghost towns and other places explored on his Guggenheim. During the shooting, Weston himself was photographing entirely in color. The only film in which he personally appears.
30 minutes, 16mm, black and white.
Available through Castle Films Division of United World Films, 1445 Park Avenue, New York, N. Y.

1957 THE NAKED EYE Film Representations. Director and producer Louis Clyde Stoumen. Narrated by Raymond Massey. Music composed and conducted by Elmer Bernstein. Contains a section on Weston.
71 minutes, 35mm, black and white.
Available through Film Representations, 251 West 42nd Street, New York, N. Y.

1965 THE DAYBOOKS OF EDWARD WESTON *Part I: How Young I Was.* Produced by the KQED—San Francisco Film Unit for National Educational Television. Written, directed and produced by Robert Katz. Camera: Philip Greene. Edited by: Robert Katz, Lela Smith. Weston's voice: Tom Rosqui. Music performed by the Mills Chamber Players.

THE DAYBOOKS OF EDWARD WESTON *Part II: The Strongest Way of Seeing.* Produced by the KQED —San Francisco Film Unit for National Educational Television. Written, directed and produced by Robert Katz. Camera: Philip Greene. Edited by: Robert Katz, Philip Greene. Weston's voice: Tom Rosqui. Music performed by the Mills Chamber Players.
Both films 30 minutes, 16mm, black and white.
First telecast not yet scheduled; probably fall of 1965. Prints can be rented or purchased from the NET Film Service, Audio Visual Department, University of Indiana, Bloomington, Indiana.

People and Places mentioned by Weston.

ROBIN—Robinson Jeffers, poet, playwright: ROAN STALLION, THE TOWER BEYOND TRAGEDY, DEAR JUDAS, etc. Lives in Carmel.

TINA—Tina Modotti, Italian-born beauty, movie actress and model to Rivera and other painters as well as to Weston, through whose teaching she became a remarkable photographer.

DIEGO RIVERA, leading mural painter of Mexican life and history; controversial political figure.

GALVAN—Manuel Hernandez Galván, Mexican Senator.

OROZCO—José Clemente Orozco, one of greatest Mexican painters.

RENE—Réné d'Harnoncourt, Count, Austrian born, at that time living in Mexico City. Now director, the Museum of Modern Art, New York.

SONYA—Sonya Noskowiak, photographer, pupil and partner of Weston during early 1930s.

MERLE ARMITAGE, impresario, typographer, publisher of books on artists including THE ART OF EDWARD WESTON, 1932, and EDWARD WESTON, FIFTY PHOTOGRAPHS, 1947.

JEAN CHARLOT, French born painter working in Mexico during 1920s; now working and teaching in Hawaii.

STIEGLITZ—Alfred Stieglitz, photographer; editor CAMERA NOTES, CAMERA WORK; founder *Photosecession* Group, galleries 291, Intimate Gallery, An American Place. Champion of the then unknown Picasso, Matisse, Cezanne, Rousseau, Brancusi, Marin, O'Keeffe, Strand, Adams, and others.

POINT LOBOS—Strange rocky peninsula three miles south of Carmel, California, kept as a Reserve by the State of California to preserve unusual and beautiful birds, animals, trees, marine life, and wildflowers.

THE BIG SUR—Huge and desolate section of California coast range below Carmel.

EDWARD WESTON: Brief Chronology

1886 Born Highland Park, Illinois.

1902 First photographs, in Chicago parks.

1906 To California on holiday; stayed.

1909 Married Flora May Chandler; four sons born: Chandler, 1910; Brett, 1911; Neil, 1914; Cole, 1919.

1911 Opened own portrait studio, Tropico, now Glendale, California.

1922 Brief journey to Ohio, New York City; photographed steel mills, met Stieglitz, Paul Strand, Charles Sheeler.

1923 To Mexico with Tina Modotti; studio in Mexico City; welcomed as master by Rivera, Siqueiros, Orozco, Charlot.

1925 Returned to U. S. for six months; studio in San Francisco.

1926 Photographed with Tina and Brett through Mexico; returned to California.

1928 Studio with Brett in San Francisco.

1929 Moved to Carmel, California.

1932 With Ansel Adams and Willard Van Dyke, led formation of Group f64.

1935 To Santa Monica with Brett.

1937 First photographer to receive Guggenheim Fellowship; traveled through California and the West.

1938 Married Charis Wilson. Guggenheim extended. His house on Wildcat Hill, Carmel, built by son Neil.

1941 Photographed through South and East for special edition of Walt Whitman's LEAVES OF GRASS; trip cut short by Pearl Harbor. Returned to Carmel; served as air raid plane spotter.

1946 Major retrospective exhibition held at Museum of Modern Art. Monograph, with bibliography, list of exhibitions, published by Museum.

1947 Worked in color while on location with Willard Van Dyke for motion picture *The Photographer*.

1948 Last photographs made at Point Lobos; stricken with Parkinson's disease.

1950 Major retrospective in Paris.

1952 With Brett's help, published FIFTIETH ANNIVERSARY PORTFOLIO.

1955 Again with Brett's help, made eight sets of prints from a thousand negatives he considered best of his life's work.

1956 THE WORLD OF EDWARD WESTON. Directed by Beaumont and Nancy Newhall. Circulated by Smithsonian Institution.

1958 Died New Year's Day, at his home at Wildcat Hill.

During his lifetime, Weston had hundreds of shows, more than he could remember or had record of, although he kept his scrapbooks quite scrupulously after 1923. He probably burned earlier ones. There have been hundreds since his death, but again only the most important are listed here. His son Cole usually has been the main force in the direction of these shows.

1960 Art Institute of Chicago. (Max McGraw collection)

1962 Staatliche Landesbildstelle Hamburg. Directed by Fritz Kempe.

1965 An Exhibition, A Tribute: THE HERITAGE OF EDWARD WESTON. 27 photographs by Edward Weston with Maxwell F. Allara, Wynn Bullock, Paul Caponigro, Alfred A. Monner, Don Normark, Gerald H. Robinson, Donald S. Ross, Brett Weston, Minor White.

1966 (with Brett Weston) Museo de Arte Moderno, Mexico City.